THE WRITER'S DESK

THE WRITER'S DESK

JILL KREMENTZ

Introduction by JOHN UPDIKE

RANDOM HOUSE NEW YORK

Grateful acknowledgment is made to those authors who wrote directly for this book: Amy Tan, Edwidge Danticat, Willie Morris, Peter Matthiessen, Cathleen Schine, Roy Blount, Jr., Ann Petry, Veronica Chambers, Richard Ford, George Plimpton. Printed by permission of the authors.

Grateful acknowledgment is made to the following for permission to reprint previously published or unpublished material:

JOHN F. BLAIR, PUBLISHER: Excerpt from an interview with Eudora Welty in *Parting the Curtains* by Dannye Romine Powell. Copyright © 1994 by John F. Blair, Publisher. Reprinted by permission of John F. Blair, Publisher.

Bomb: Excerpt from an interview with Russell Banks by Pinckney Benedict (summer 1995). Reprinted by permission of *Bomb* magazine.

CARLTON CREMEENS: Excerpt from a 1968 interview with Walker Percy. Reprinted by permission of Carlton Cremeens.

DUTTON SIGNET, A DIVISION OF PENGUIN BOOKS USA INC.: Excerpt from page 112 of *The Van Wyck Brooks/Lewis Mumford Letters,* edited by Robert E. Spiller. Copyright © 1970 by E. P. Dutton. Used by permission of Dutton Signet, a division of Penguin Books USA Inc.

THE ESTATE OF TERRY SOUTHERN: Excerpt from the unpublished text "Drugs and the Writer." Printed by permission of the Estate of Terry Southern.

Martha's Vineyard Magazine: Excerpt from "Island Neighbors" (from "When I was seven" to "I want to write"), an article about Dorothy West by Julia Wells (summer 1990). Copyright © 1990 by *Martha's Vineyard Magazine.* Reprinted by permission of *Martha's Vineyard Magazine.*

THE NEW YORK TIMES COMPANY INC.: Excerpt from "Imagining Life" (from "I work" to "anything like that"), an article about Mona Simpson by Susannah Hunnewell in *The New York Times Book Review* (February 9, 1992). Copyright © 1992 by The New York Times Company Inc. Reprinted by permission of The New York Times Company Inc.

The Paris Review: Excerpts from various interviews which appeared in *The Paris Review.* Reprinted by permission of *The Paris Review.*

Publishers Weekly: Excerpt from an interview with Ross Macdonald by Barbara A. Bannon (August 9, 1971). Copyright © 1971 by Publishers Weekly. Reprinted by permission.

RUTGERS UNIVERSITY PRESS: Excerpt from an interview with Terrence McNally in *The Playwright's Art,* edited by Jackson R. Bryer. Copyright © 1995 by Rutgers, The State University. Reprinted by permission of Rutgers University Press.

CLAUDIA TATE: Excerpt from a 1983 interview with Nikki Giovanni. Reprinted by permission of Claudia Tate.

UNIVERSITY OF ILLINOIS PRESS: Excerpt from an interview with Joyce Carol Oates in *The New Fiction* by Joe David Bellamy. Copyright © 1974 by the Board of Trustees of the University of Illinois. Reprinted by permission of University of Illinois Press and Joe David Bellamy.

THE WASHINGTON POST WRITER'S GROUP: Excerpt from "A Narrow World Made Wide," an article about Rita Dove by Walt Harrington (May 7, 1995). Copyright © 1995 by The Washington Post. Reprinted by permission of The Washington Post Writer's Group.

JAMES L. W. WEST, III: Excerpt from a 1974 interview with William Styron (from "I've never written any prose" to "an added handicap"). Reprinted by permission of James L. W. West, III.

JAY WOODRUFF: Excerpt from a 1991 interview with Robert Coles. Reprinted by permission of Jay Woodruff.

Library of Congress Cataloging-in-Publication Data
Krementz, Jill.
 The writer's desk/Jill Krementz; introduction by John Updike.
 p. cm.
 ISBN 0-679-45014-9 (alk. paper)
 1. Authors, American—20th century—Portraits. 2. Authors,
English—20th century—Portraits. 3. Authors—20th century—
Portraits. 4. Desks—Pictorial works. 5. Authorship. I. Title.
PS137.K64 1996
810.9'0054—dc20 96-34451

Random House website address: http://www.randomhouse.com/

Printed in the United States of America on acid-free paper.
 3456789

Book design by Wynn Dan

Eugene Merinov has been printing
my photographs for twenty years.
He is an artist and a friend.
This book is dedicated to him
with my gratitude and love.

Contents

Introduction by John Updike

I look at these photographs with a prurient interest, the way that I might look at the beds of notorious courtesans. Except that the beds would tell me less than these desks do. Here the intimacy of the literary act is caught *in flagrante delicto:* at these desks characters are spawned, plots are spun, imaginative distances are spanned.

The sheets are often mussed. Robert Penn Warren has papers overflowing his typing table and adjacent surfaces and even underfoot—his feet are virtually bare, as if he is about to tread grapes. Joan Didion's are totally bare. William Maxwell is in his pajamas and bathrobe. So is Kurt Vonnegut, who works on his lap, while crouching at a shelf that does for a desk. Terry Southern has a lot of copies of *Candy* on his desk, a whiskey glass in his hand, and the challenging word ROCK tacked to a bulletin board. John Cheever has equipped himself with a glass and not one but *two* packs of cigarettes. George Plimpton is evidently able to concentrate amid a vivacious clutter of books and mementos, while the floor holds bright splashes of sunlight and a pair of twin infants lustily sucking on twin bottles. Robert Coles's piled books are reaching for the ceiling, and Jean Piaget calmly lights his pipe of meditation amid a mountainous clutter of stratified books and folders, not to mention what appears to be two radios one on top of the other.

On the other hand, Georges Simenon has at least twenty pipes lined up impeccably, on a desk whose objects are subdued to parade formation. There is a tidy, minimalist school of desk decor. E. B. White and Archibald MacLeish,

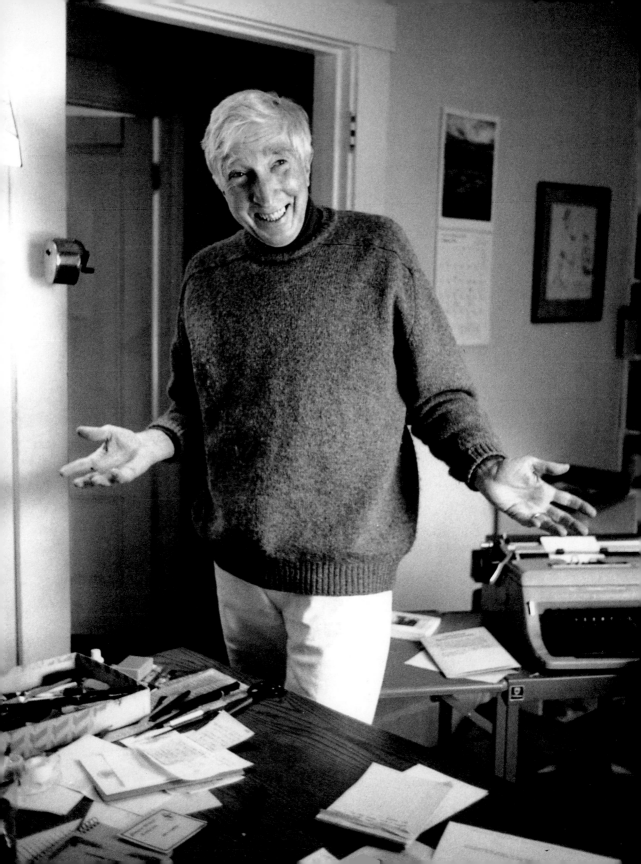

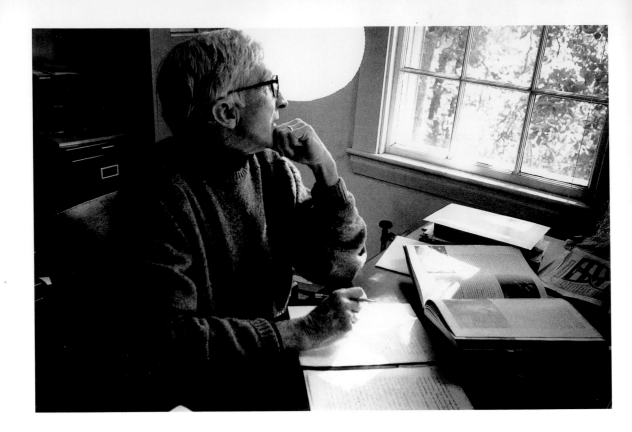

both in rural retreat, work next to open windows, on bare plain wood. Lewis Mumford displays a system of suspended clips on hooks that suggests a factory foreman keeping track of rush orders. Willie Morris and Susan Sontag go in for long, long desks, where the reach for inspiration is physicalized, whereas Rita Dove and Anthony Powell work at spaces that are conspicuously small, as if to keep marginalia at bay. Isaac Bashevis Singer perches self-effacingly at the end of a desk, like the coxswain of a racing shell. Thornton Wilder and James Merrill project a sense of being literary gentlemen of Connecticut, at home in dignified clutter. The two most commercially successful authors herein, Stephen King and James Michener, wear blue-collar clothes in an industrial-looking environment—though King occupies less space than his tremendous production would seem to warrant, and he shares it furthermore with a dog. (Dogs outnumber cats as quadrupedal muses two to one.) P. G. Wodehouse and Pablo Neruda, two authors seldom otherwise bracketed, are both conspicuous in the wearing of jackets and neckties at their desks, while pursuing an occupation notably informal in its traditional garb.

And then there are those who, at least within the ken of Jill Krementz's camera, abjure desks entirely. Saul Bellow, the American writer supreme, stands erect at a drawing board. Toni Morrison, our most recent Nobel Laureate, sits on a sofa with a lined notebook. William Buck-

ley dictates in the back of a car, Ross Macdonald has constructed a kind of bed for himself, and Walker Percy and Cathleen Schine are actually in bed, a classic writing site utilized by Edith Wharton, Colette, Proust, and James Joyce, who sprawled across his and Nora's bed in a riot of notes to himself. I am struck by the wealth of photos, trinkets, and mementos with which John Irving, Nikki Giovanni, and Peter Matthiessen have crowded the walls and sills of their work area, for the requirement of any writing space is that it disappear from the mind's eye of the inhabitant, to be replaced with the verbal vistas of poetry and prose. A desk surrounded by too many lively souvenirs might seem to clamor with the claims of the life—trivial, busy, egocentric life—away from the desk; but better these than strange sights, which demand fresh attention. From Twain to Fitzgerald, American writers have set up shop in German castles or Italian villas to get away from it all and immerse themselves in the otherworld of a book. Some still hold to the practice, and find ease in the neutrality of a strange hotel room; for most, the shortest distance for the imagination to travel is from a familiar corner of their home.

Desks want to get messy. Letters and importunate unsolicited manuscripts and bound galleys pathetically crying for attention hang out at the corners, until they fall off. In my own writing quarter—four little "maid's rooms," with lavatory, in a generous-scaled old summer house—I have three desks, each of a different substance and each trained to support a different activity. An oak desk bought at Furniture in Parts in Boston twenty years ago is, along with a metal

typing table and an old manual Olivetti, where I answer letters and talk on the phone. An olive-drab steel desk, a piece of retired Army equipment bought over thirty years ago in Ipswich, is where I write by hand, when the fragility of the project—a poem, the start of a novel—demands that I sneak up on it with that humblest and quietest of weapons, a pencil. Also this desk, whose ample surface (annoyingly dented in the center by some mishap in its previous career) I try to keep relatively empty, is where I read proofs, comparing a novel's successive versions side by side. The third desk, veneered in white Formica, holds the word processor where everything gets typed up and many items, including this introduction, are composed. Being able to move from desk to desk, like being able to turn over in bed, solves some cramps and fidgets and stratifies the authorial persona: the wooden desk serves the man of the world, the Formica the functioning professional, and the old Army desk the tentative, tender creator, who still hopes to establish, in this clumsy, improvised setting, some connection with the ethereal and everlasting spirit of literature.

Our task as we sit (or stand or lie) is to rise above the setting, with its comforts and distractions, into a relationship with our ideal reader, who wishes from us nothing but the fruit of our best instincts, most honest inklings, and firmest persuasions. This ideality can be courted, as we see here, in a wide range of bowers, from a bare boathouse (E. B. White) and a mysteriously timbered back room (Edwidge Danticat) to living spaces ornate with signs of bourgeois comfort. Comfort is relative—Katherine Anne Porter's

crowded table, with its lean rush-seated chair, was comfort to her, as is Dorothy West's "mess" of papers, which have spread, fluttering, up the walls. What is crucial is a sense of ease that frees the mind. And yet the atmosphere should not be so easy as to discourage a day's worth of uphill work. Writing—the leap onto the blank paper, the precarious linkage of one sentence to the next—is labor of a peculiarly exhausting sort. The goal of perfection, for which the classics are our measure, is intimidating enough to freeze fine minds and pure hearts into permanent silence. It helps, perhaps, to have an impending engagement—a lunch date, a golf date, or a long-contemplated outdoor chore—to concentrate the mind. Otherwise, our energy spreads itself thin over the available hours and the meanders of possible rewording. Much time can be wasted, but in the end it must be seized. The most pro-lific living author here, Joyce Carol Oates, claims, "Most of the time I do nothing. . . . I waste most of my time, in daydreaming, in drawing faces on pieces of paper." Even more surprisingly, John Ashbery, to whom inspiration is so readily available that he composes his poems on a typewriter, professes to have fewer "hang-ups and rituals" than he used to: "I feel blocked much less often, though it still happens." If these two writers sometimes stall, what doubts and procrastinations waylay the rest of us?

On the desks shown here, the once-ubiquitous ashtray has over time yielded its place to the word-processor keyboard; the piece of paper rolled into the typewriter's platen is now a screen framed in icons. Four of the younger generation, Cathleen Schine, Mona Simpson, Amy Tan, and Veronica Chambers have moved on to laptops, which can turn an airplane seat into a desk in the sky. Jill Krementz's photographs, in all their variety of milieu and demeanor, generally show people at peace in their settings, their activity, and their poses. Writing at its inner source is a deeply comforting activity, an ordering and a purging and a bringing into the light what had been hid-den an hour before. These desktops and nooks are happy places—chaste beds of conception, rumpled and warm.

BEVERLY FARMS, MASSACHUSETTS, 1996

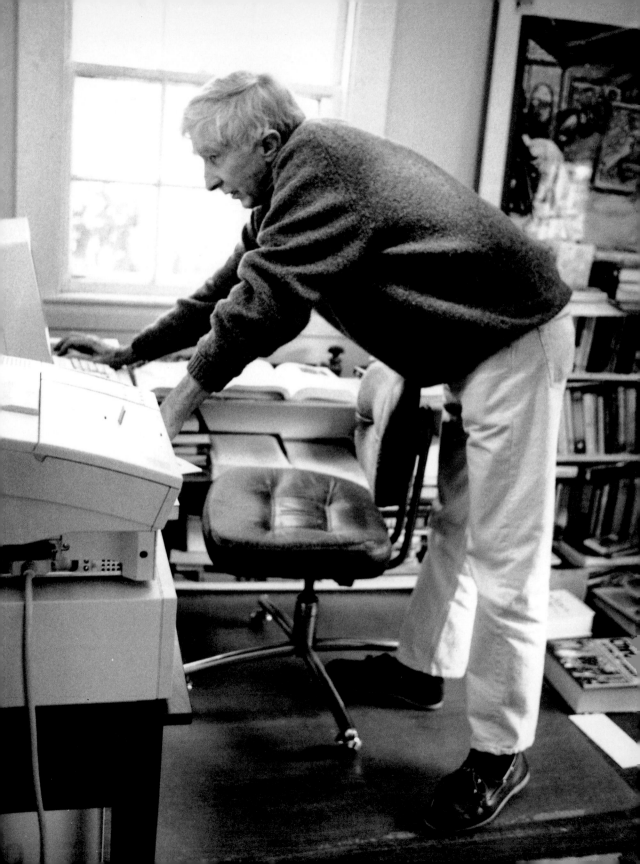

THE WRITER'S DESK

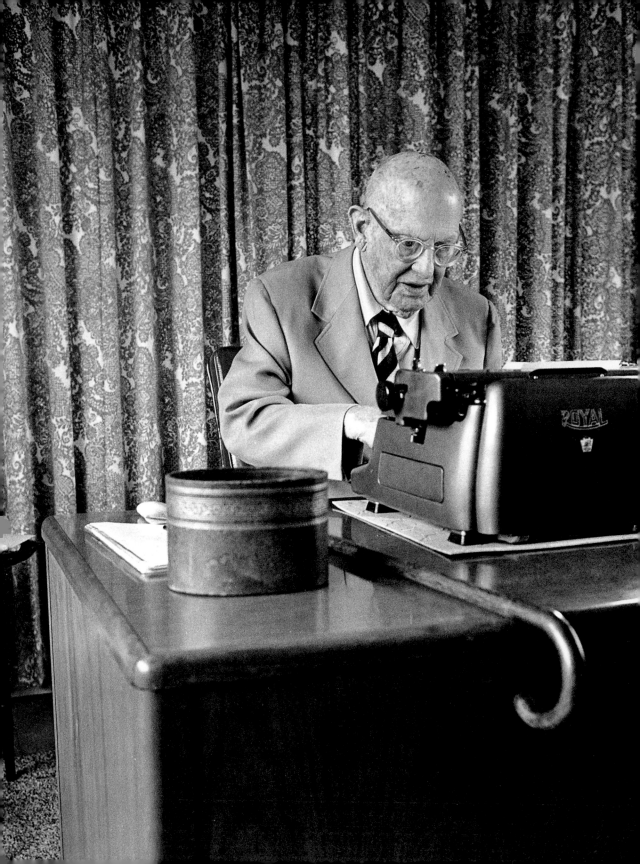

P. G. Wodehouse

It's curious how a scenario gets lost as you go along. I don't
think I've ever actually kept completely to one. If I've got a
plot for a novel worked out and I can really get going on it, I
work all the time. I work in the morning, and then I probably
go for a walk or something, and then I have another go at the
novel. I find that from four to seven is a particularly good time
for working. I never work after dinner. It's the plots that I find
so hard to work out. It takes such a long time to work one out.
I like to think of some scene, it doesn't matter how crazy, and
work backward and forward from it until eventually it
becomes quite plausible and fits neatly into the story.

I've just finished another novel, in fact. . . . It really is funny.
It's worked out awfully well. I'm rather worried about the
next one. It will be a letdown almost. I don't want to be like
Bernard Shaw. He turned out some awfully bad stuff in his
nineties. He said he knew the stuff was bad but he
couldn't stop writing.

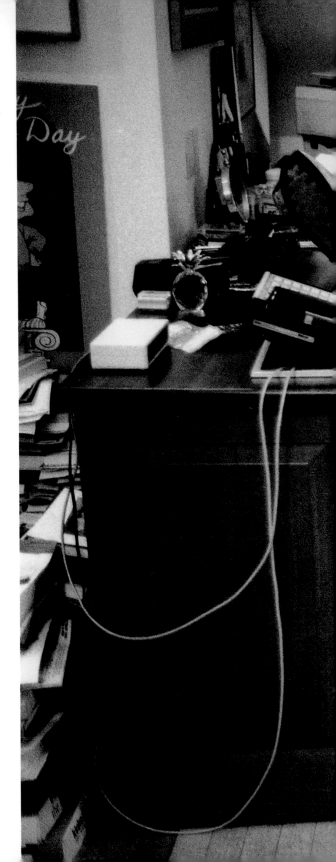

Stephen King

I work on what's important to me in the morning, for three hours. Usually, in the afternoon, I have what I call my "toy truck," a story that might develop or might not, but meanwhile it's fun to work on. . . . I begin to pile up some pages, and eventually it'll get shifted over to the morning. . . . Working on a new idea is kind of like getting married. Then a new idea comes along and you think, "Man, I'd really like to go out with her." But you can't. At least not until the old idea is finished. . . .

I don't take notes; I don't outline; I don't do anything like that. I just flail away at the goddamned thing. . . . I'm a salami writer. I try to write good salami, but salami is salami. You can't sell it as caviar.

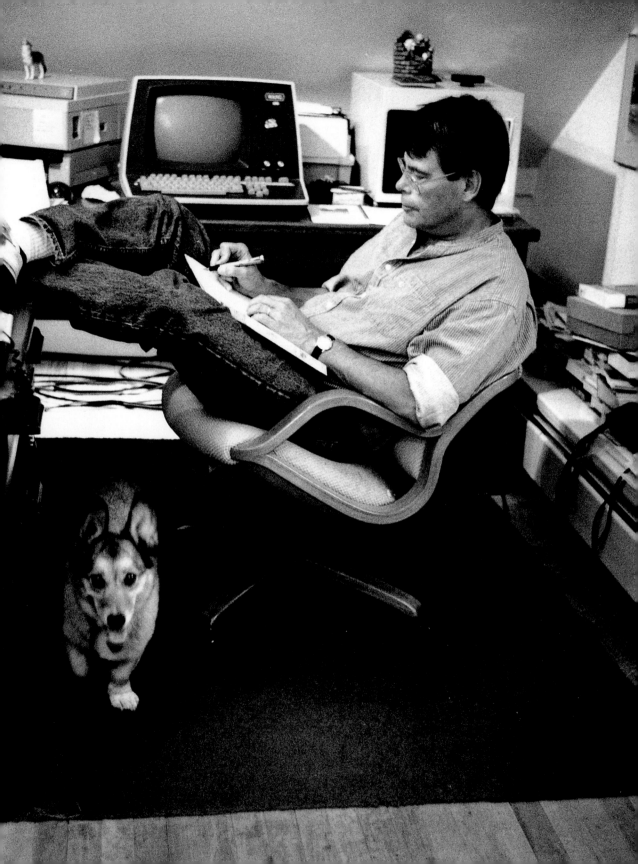

John Irving

I don't give myself time off or
make myself work; I have no
work routine. I am compulsive
about writing. I need to do it the
way I need sleep and exercise
and food and sex; I can go with-
out it for a while, but then I
need it. A novel is such a long
involvement; when I'm begin-
ning a book, I can't work more
than two or three hours a
day. . . . Then there's the middle
of a book. I can work eight,
nine, twelve hours then, seven
days a week—if my children let
me; they usually don't. . . . An
eight-hour day at the typewriter
is easy; and two hours of read-
ing over material in the
evening, too. That's routine.
Then when the time to finish
the book comes, it's back to
those two- and three-hour days.
Finishing, like beginning, is
more careful work. . . . It takes
me nearly as long to rewrite a
book as it does to get the first
draft. I can write more quickly
than I can read.

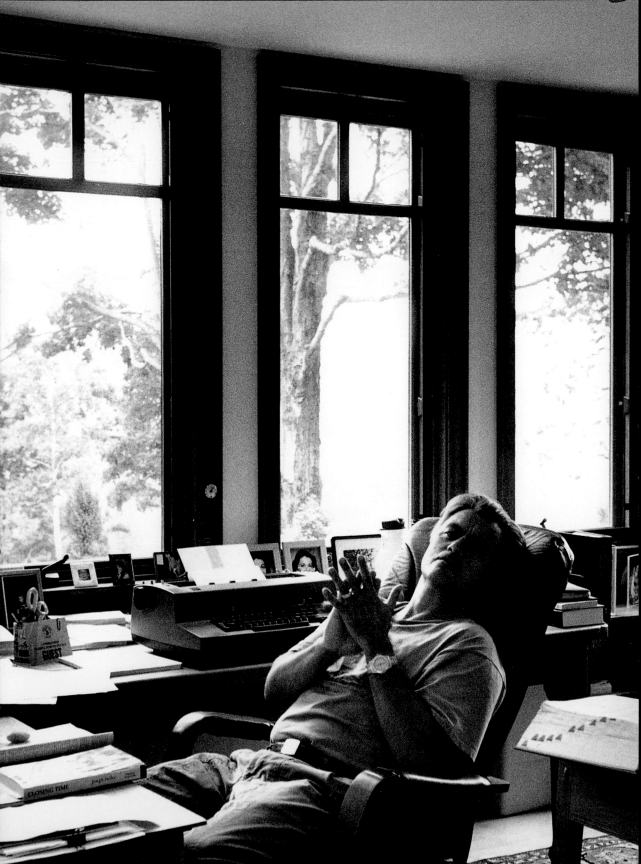

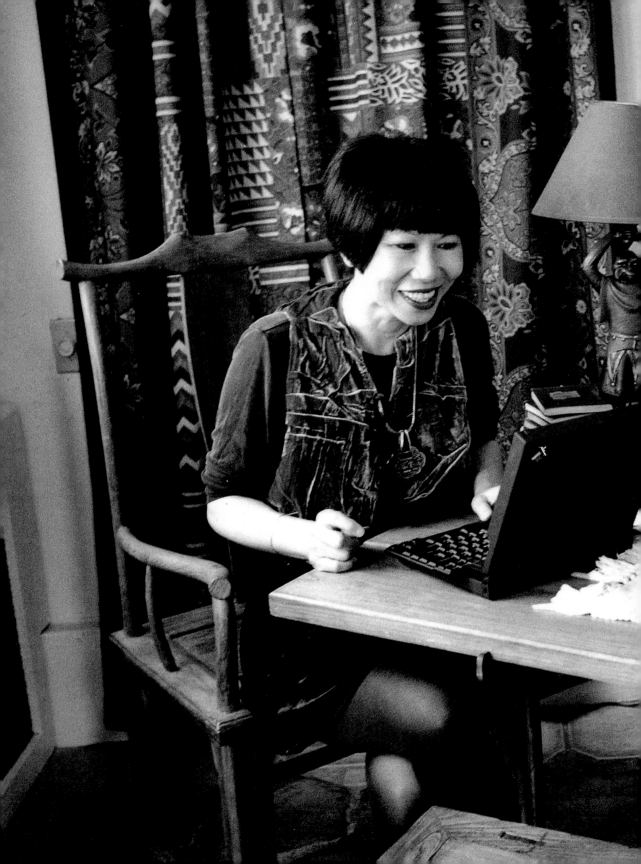

Amy Tan

I surround myself with objects that carry with them a personal history— old books, bowls and boxes, splintering chairs and benches from imperial China. I imagine the people who once turned the pages or rubbed their palms on the surfaces. While they were thinking—thinking what? And then I hear my yappy little dog. Bubba Zo is my distraction, my reminder to get up and go for a walk before he pees on the carpet. I now include a lot of dog metaphors in my writing.

Jean Piaget

As you know, Bergson pointed out that there is no such thing as disorder but rather two sorts of order, geometric and living. Mine is clearly living. The folders I need are within reach, in the order of the frequency with which I use them. True, it gets tricky to locate a folder in the lower levels. But if you have to find it, you look for it. That takes less time than putting them away every day.

In my whole life I've lost only one paper. It was about the plants I'm still studying, the sedums, and I had written an article about them. Then I just couldn't locate it; I had to rewrite it. It's one of the rare instances when I am in complete agreement with Freud about lapses and errors in action. I certainly lost it on purpose; it wasn't good.

My wife is kind enough not to touch anything.

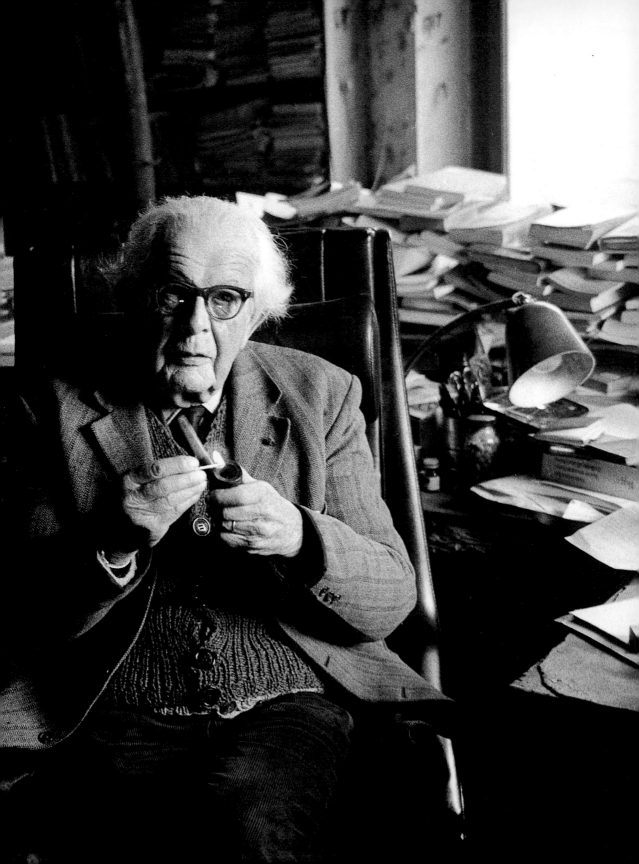

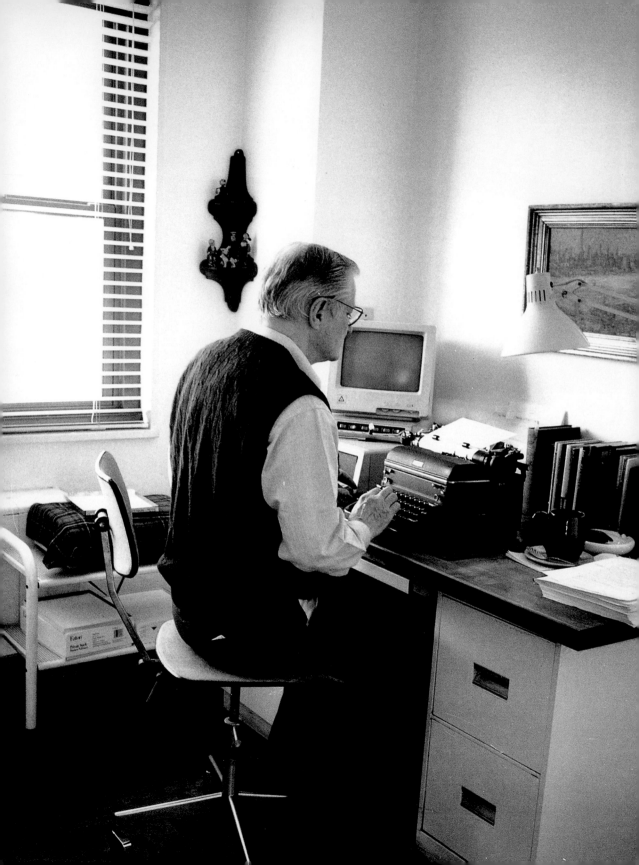

John Ashbery

I write on the typewriter. I didn't use to. . . . Occasionally I write a poem in longhand to see whether I can still do it. I don't want to be forever bound to this machine, this very old, circa 1930 I would say, Royal typewriter. I hate to think what will happen when it finally gives out, though you can still find them sometimes in those used office furniture stores on West 23rd Street, which are themselves an endangered species.

I can't really work at night. Nor in the morning, very much, when I have more ideas but am less critical of them, it seems. . . . On the whole, I believe I have fewer hang-ups and rituals than I used to. I feel blocked much less often, though it still happens. It's important to try to write when you are in the wrong mood or the weather is wrong. Even if you don't succeed you'll be developing a muscle that may do it later on. And I think writing does get easier as you get older. It's a question of practice and also of realizing you don't have the oceans of time to waste you had when you were young.

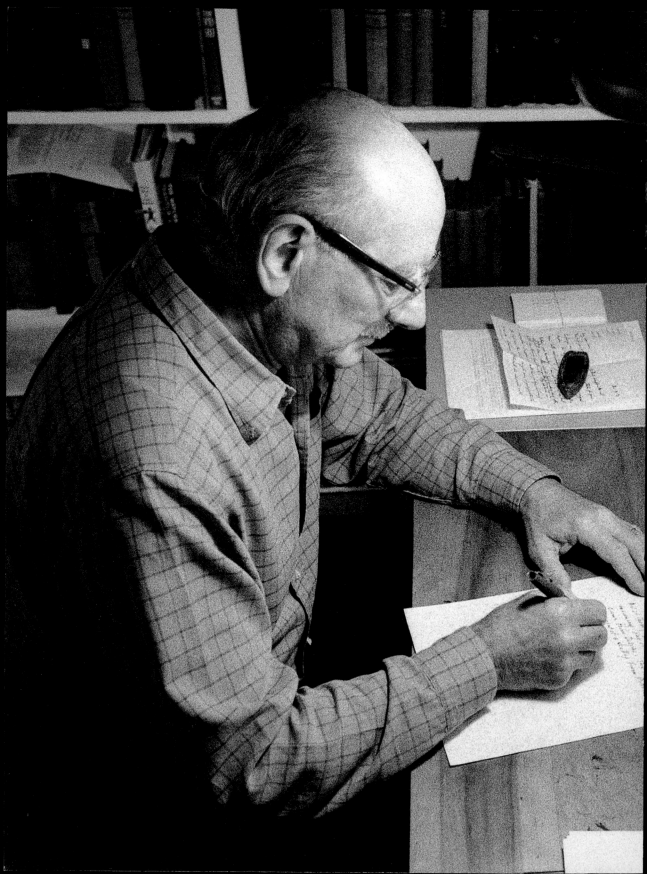

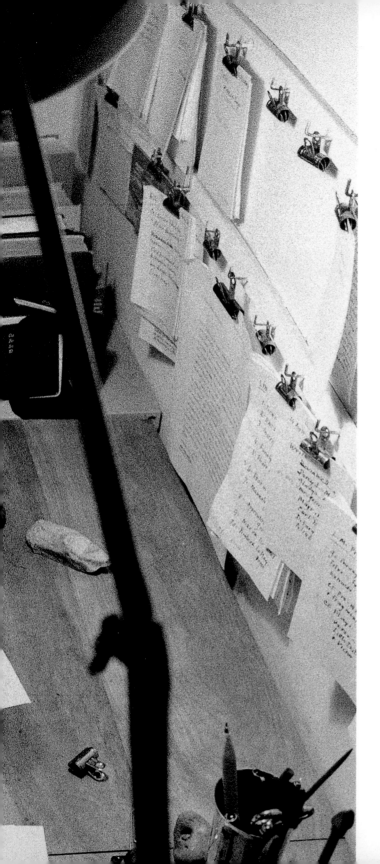

Lewis Mumford

To Van Wyck Brooks, 4/12/35:
I trust you are back in stride with
more to show for the last few
months than I can. At least you
have not been spending your time
in aimless Pullman cars, like a
Thomas Wolfe hero, have not been
dispersing yourself in unimportant
lectures to vacuous people, have
not been showing, as I have, latent
capacities for mob oratory in
addressing groups on War and
Fascism. One is damned in one's
work, not by the cohorts of Satan,
against whom one is on one's
guard; but by all the little Children
of Light who bait one with their
good intentions and make one sur-
render one's proper virtue in the
interests of *their* virtue, as if, in the
long run, that could be more impor-
tant. Henceforward, I shout to the
heavens, I shall deliver no more lec-
tures on behalf of good causes: I am
the good cause that denies the need
for such lectures. Avaunt! impor-
tuning world! Back to my cell. . . .

15

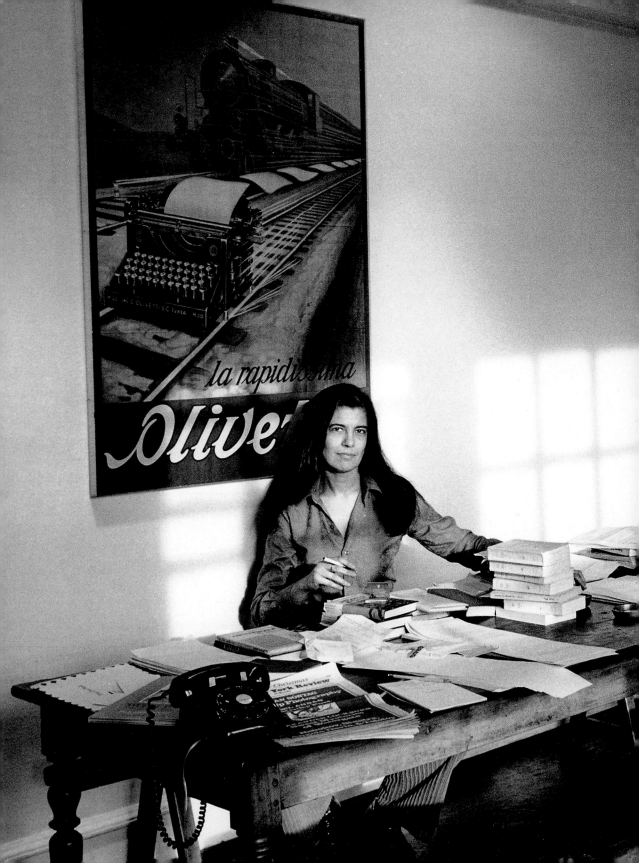

Susan Sontag

Getting started is partly stalling, stalling by way of reading and of listening to music, which energizes me and also makes me restless. Feeling guilty about *not* writing. . . . But once something is really under way, I don't want to do anything else. I don't go out, much of the time I forget to eat, I sleep very little. It's a very undisciplined way of working and makes me not very prolific. But I'm too interested in many other things.

Writing requires huge amounts of solitude. What I've done to soften the harshness of that choice is that I don't write all the time. I like to go out—which includes traveling; I can't write when I travel. I like to talk. I like to listen. I like to look and to watch. Maybe I have an Attention Surplus Disorder. The easiest thing in the world for me is to pay attention.

John Cheever

The sense is of one's total usefulness. We all have a power of control, it's part of our lives: we have it in love, in work that we love doing. It's a sense of ecstasy, as simple as that. It always leaves you feeling great. In short, you've made sense of your life.

All sorts of pleasant and intelligent people read [my] books and write thoughtful letters about them. I don't know who they are, but they are marvelous and seem to live quite independently of the prejudices of advertising, journalism, and the cranky academic world. . . . The room where I work has a window looking into a wood, and I like to think that these earnest, loveable, and mysterious readers are in there.

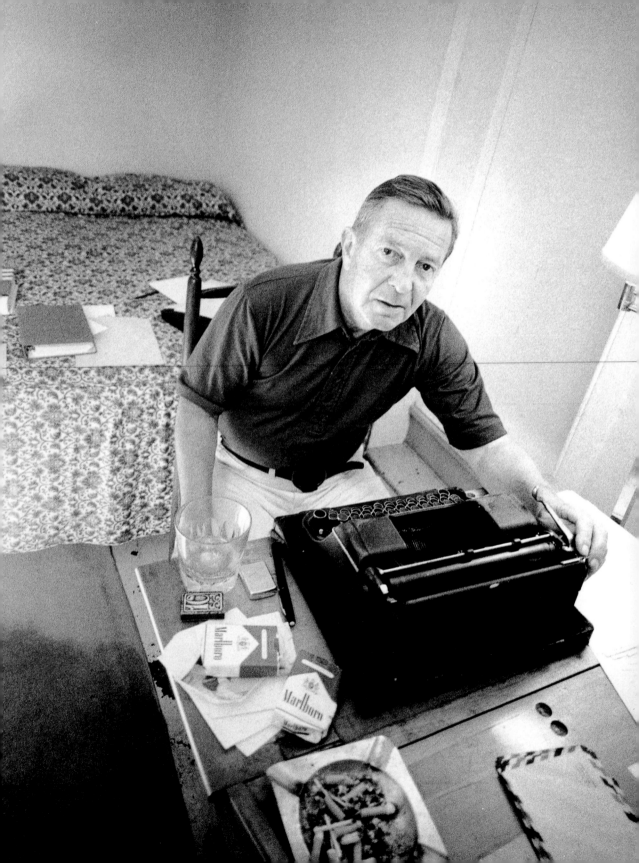

Edwidge Danticat

I began to write as a child, starting with some journals describing what happened to me each and every day. My uncle Joseph bought me Ludwig Bemelmans's Madeline books in French, along with other short novels that featured moments of adventure which little girls created in their own lives. I remember thinking after reading these books that I could write similar things about myself. I put together some pieces of paper and sewed them into a notebook and wrote my own stories: *Edwidge in School,* even *Edwidge in the Provinces,* where I spent most of my summers as a girl.

Now as a woman, I dream of having a little girl named Sophie who could help me read these stories with the same kind of pleasure again. After I'm gone, I want little Sophie to have a legacy. I see Sophie's daughters saying, "My grandmother Edwidge came here to America when she was twelve and she became a writer." My writing is the truest thing I can leave behind for them.

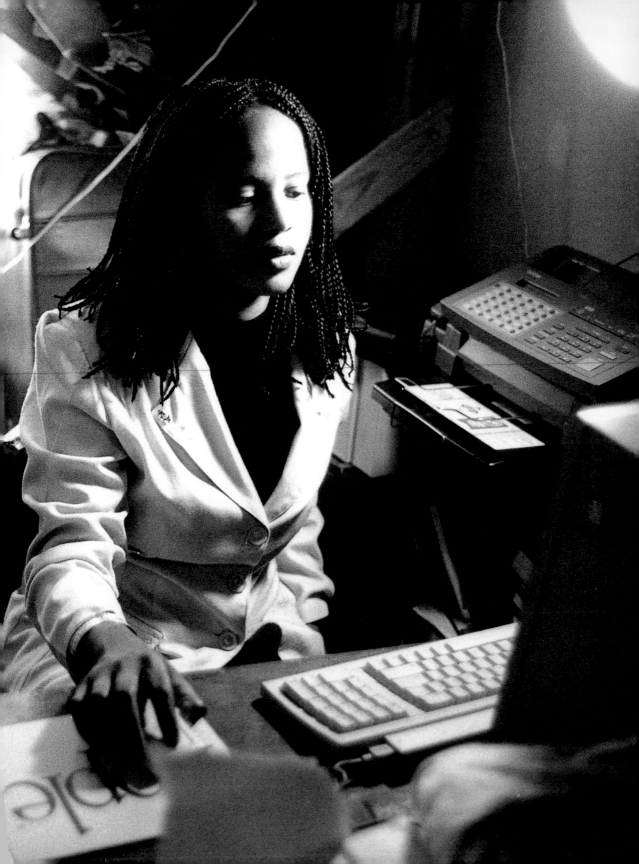

Bernard Malamud

You write by sitting down and writing. There's no particular time or place—you suit yourself, your nature. How one works, assuming he's disciplined, doesn't matter. If he or she is not disciplined, no sympathetic magic will help. The trick is to make time—not steal it—and produce the fiction. If the stories come, you get them written, you're on the right track. Eventually everyone learns his or her own best way. The real mystery to crack is you.

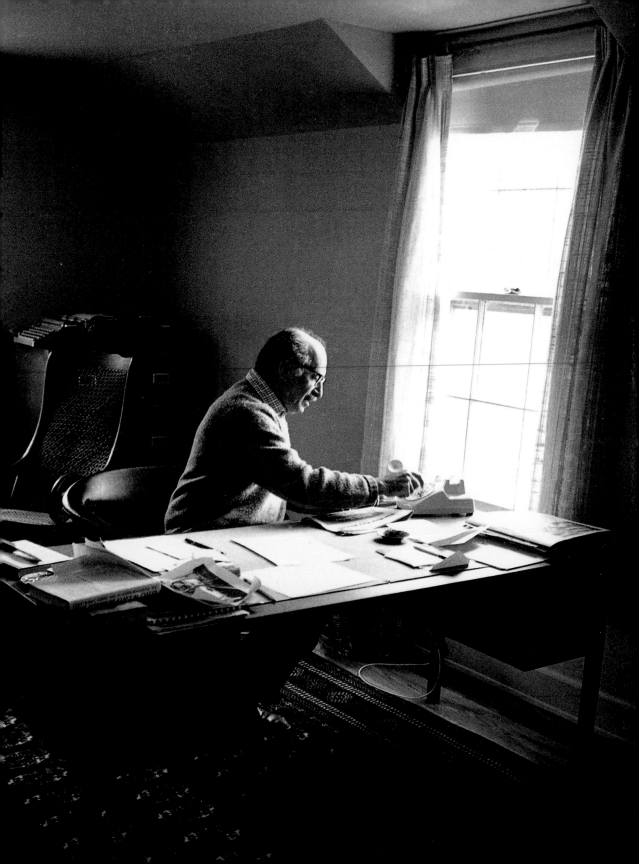

Pablo Neruda

Ever since I had an accident in which I broke a finger and couldn't use the typewriter for a few months, I have followed the custom of my youth and gone back to writing by hand. I discovered when my finger was better and I could type again that my poetry when written by hand was more sensitive; its plastic forms could change more easily.... The typewriter separated me from a deeper intimacy with poetry, and my hand brought me closer to that intimacy again.

I don't have a schedule, but by preference I write in the morning.... I would rather write all day, but frequently the fullness of a thought, of an expression, of something that comes out of myself in a tumultuous way—let's label it with an antiquated term, "inspiration"—leaves me satisfied, or exhausted, or calmed, or empty. That is, I can't go on.

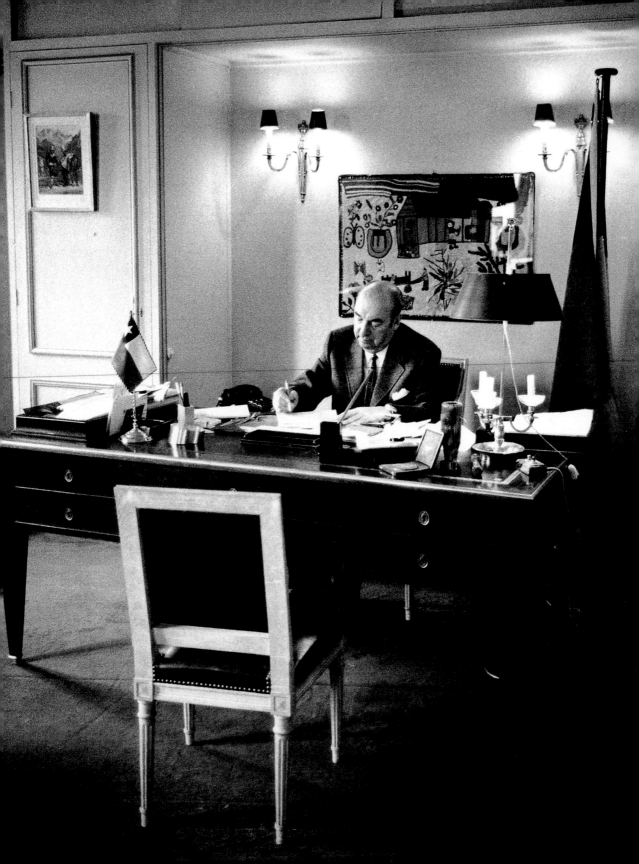

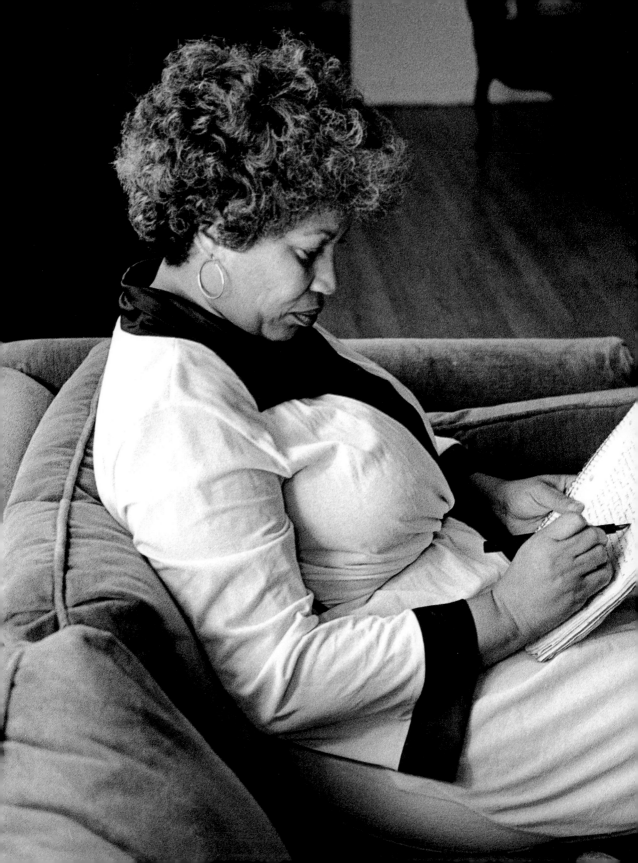

Toni Morrison

Recently I was talking to a writer who described something she did whenever she moved to her writing table. I don't remember exactly what the gesture was—there is something on her desk that she touches before she hits the computer keyboard—but we began to talk about little rituals that one goes through before beginning to write. I, at first, thought I didn't have a ritual, but then I remembered that I always get up and make a cup of coffee while it is still dark—it must be dark—and then I drink the coffee and watch the light come. And she said, well, that's a ritual. And I realized that for me this ritual comprises my preparation to enter a space that I can only call nonsecular.... Writers all devise ways to approach that place where they expect to make the contact, where they become the conduit, or where they engage in this mysterious process. For me, light is the signal in the transition. It's not being *in* the light, it's being there *before it arrives*. It enables me, in some sense.

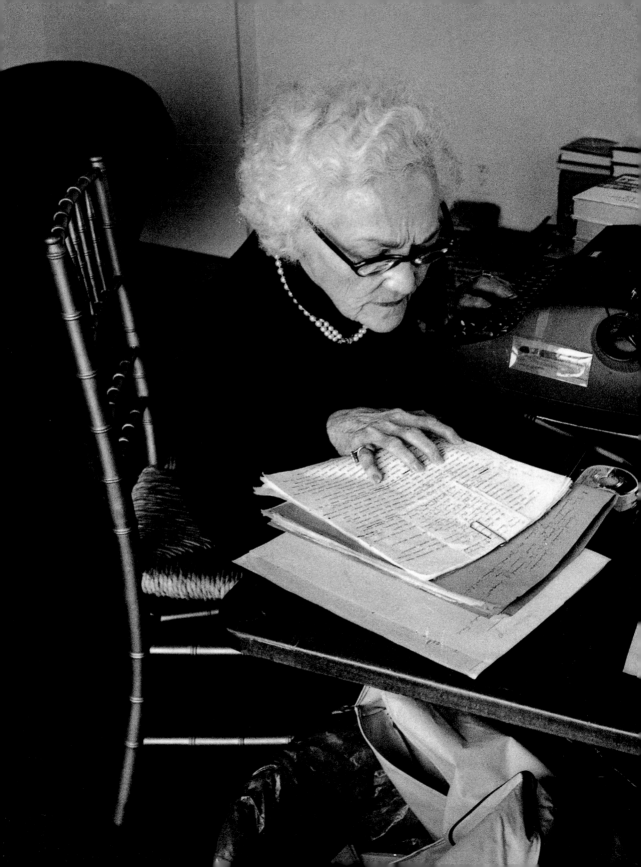

Katherine Anne Porter

I can live a solitary life for months at a time, and it does me good, because I'm working. I just get up bright and early—sometimes at five o'clock— have my black coffee and go to work. In the days when I was taken up with everything else, I used to do a day's work, or housework or whatever I was doing, and then work at night. I worked when I could. But I prefer to get up very early in the morning and work. I don't want to speak to anybody or see anybody. Perfect silence. I work until the vein is out. There's something about the way you feel, you know when the well is dry, that you'll have to wait till tomorrow and it'll be full up again.

If I didn't know the ending of a story, I wouldn't begin. I always write my last lines, my last paragraph, my last page first, and then I go back and work towards it. I know where I'm going. I know what my goal is. And how I get there is God's grace.

E. B. White

A girl pushing a carpet sweeper under my typewriter table has never annoyed me particularly, nor has it taken my mind off my work, unless the girl was unusually pretty or unusually clumsy. My wife, thank God, has never been protective of me, as, I am told, the wives of some writers are. In consequence, the members of my household never pay the slightest attention to my being a writing man—they make all the noise and fuss they want to. If I get sick of it, I have places I can go.

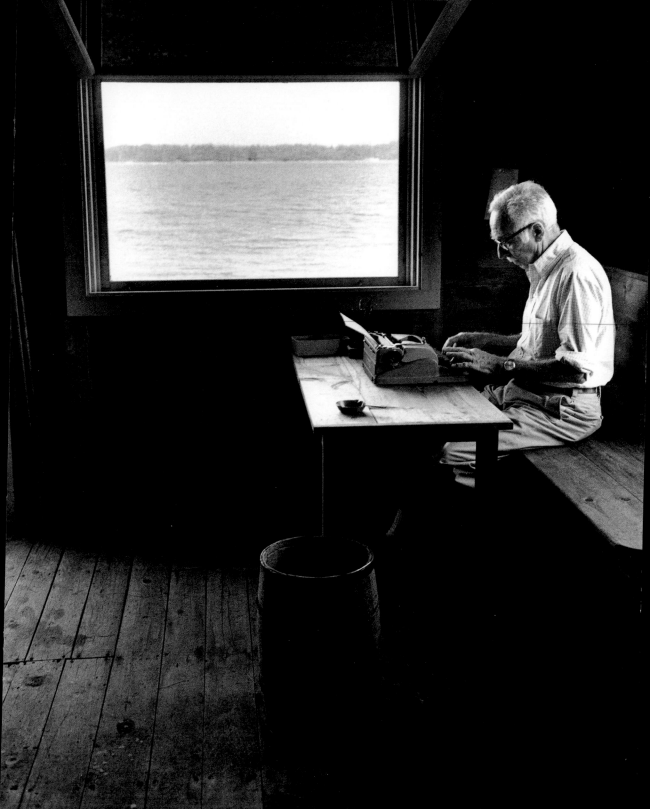

Terrence McNally

It's very simple, really. You have to go to the typewriter, that's all you have to do. I have a word processor now, and you turn it on and something happens after a while, and that's all writing is to me. If I don't go to the typewriter I don't write. I'm not being facetious. I think it's a very practical thing, and deadlines help a lot. You realize that *Lips Together* opens April twelfth and it's December twelfth and you haven't written a word of the play. I carry them up in my head for a long time. That process is very hard to talk about. It's partially my unconscious. It's usually a year or two before I sit at the typewriter, but people say, "God, you write plays so quickly." Well, I think walking around with things in your head for two years is not exactly quickly. The typing part is pretty quick, if you really know what you're doing in a play.

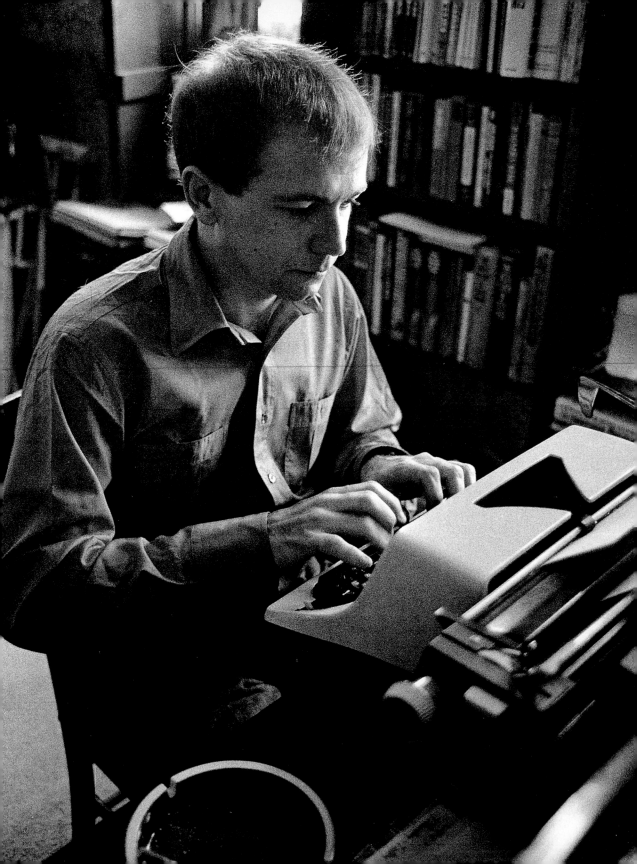

Thornton Wilder

Many writers have told me
that they have built up
mnemonic devices to start
them off on each day's writing
task. Hemingway once told
me he sharpened twenty
pencils; Willa Cather that she
read a passage from the Bible
(not from piety, she was quick
to add, but to get in touch
with fine prose; she also
regretted that she had formed
this habit, for the prose
rhythms of 1611 were not
those she was in search of).
My springboard has always
been long walks. I drink a
great deal, but I do not
associate it with writing.

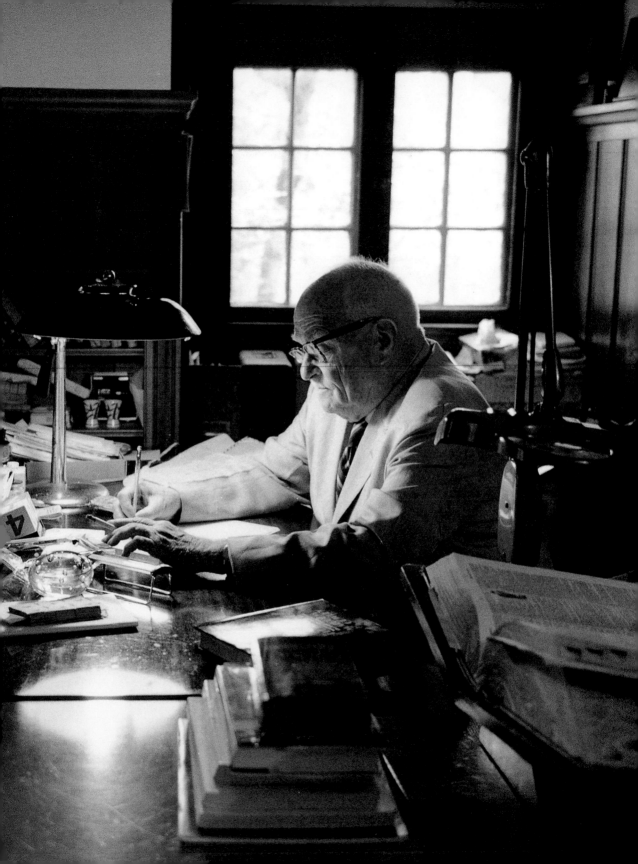

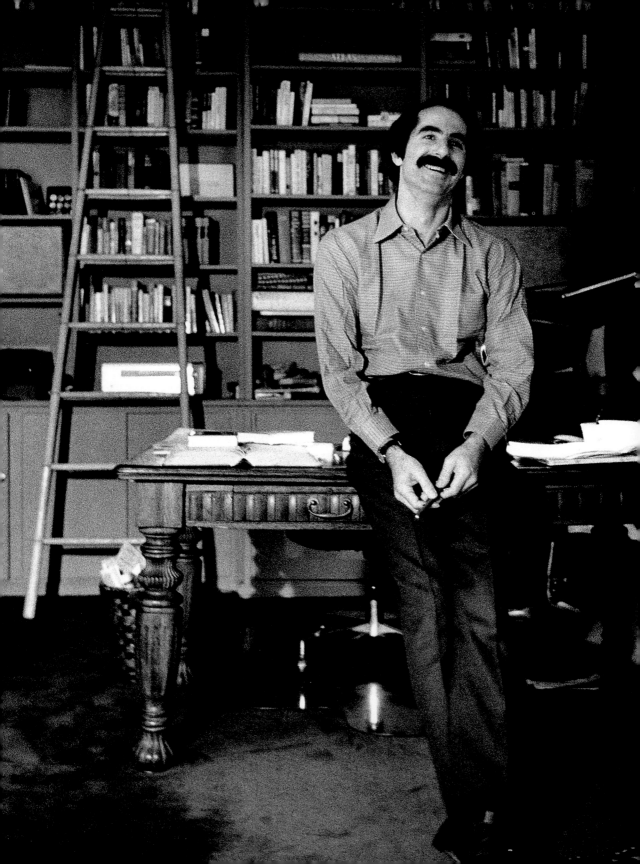

Philip Roth

I don't ask writers about their work habits. I really don't care. Joyce Carol
Oates says somewhere that when writers ask each other what time they
start working and when they finish and how much time they take for
lunch, they're actually trying to find out, "Is he as crazy as I am?" I don't
need that question answered.

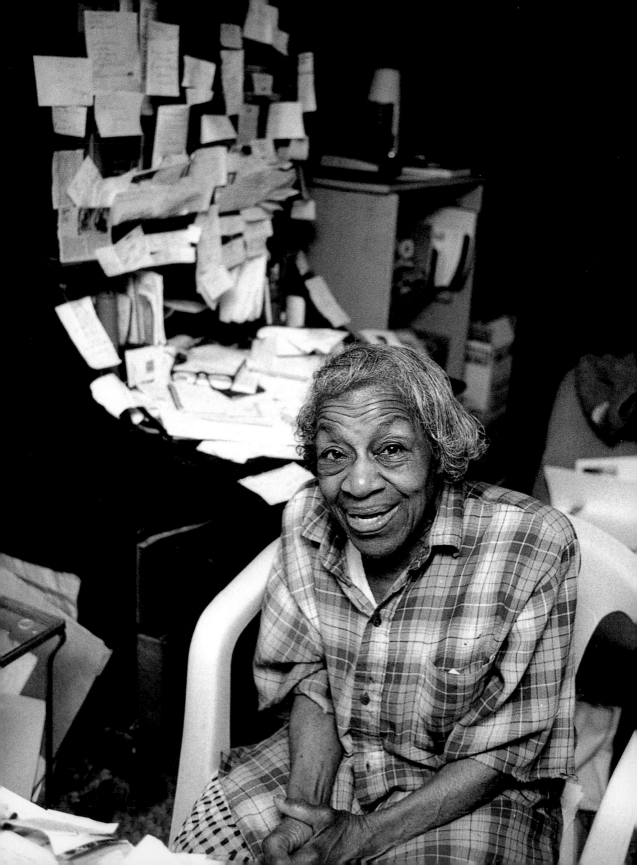

Dorothy West

I'm a writer. I don't cook and I don't clean. . . . Dear child, this place is a mess—my papers are everywhere. It would be exhausting to clean up! . . .

I can't believe I'm eighty-seven. As a child, I decided I never wanted to be the last leaf on the tree, and now here I am, the last leaf. I was a member of the Harlem Renaissance, you know, and the youngest person is the one who lives the longest. . . .

When I was seven, I said to my mother, may I close my door? And she said, yes, but why do you want to close your door? And I said because I want to think. And when I was eleven, I said to my mother, may I lock my door? And she said yes, but why do you want to lock your door? And I said because I want to write.

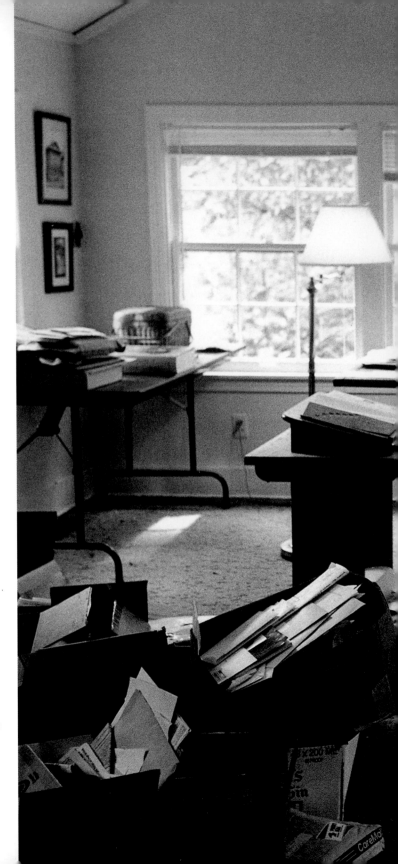

Willie Morris

I'm an afternoon writer. I draw sustenance from my strange nocturnal dreams. My workroom is on the second floor of an old Mississippi house. I work on an enormous oak table that I had especially built. Friends are always surprised that my table is relatively well-organized. I gaze out the window a lot, down onto undulating Southern terrain leading to Purple Crane Creek, which overflows in rains.

My cat, Spit McGee, who has one brown eye and one blue and is named after a swamp boy in a children's book I once wrote, often jumps on the table and gets in my way, usually sprawling languidly on my manuscript. I write in longhand, and he quizzically looks down at my words. What is the old fool doing now? he seems to be asking. I welcome these intrusions when I'm starting a new book, because the book takes a little time to unfold. Once it does, I make Spit McGee sit on the floor.

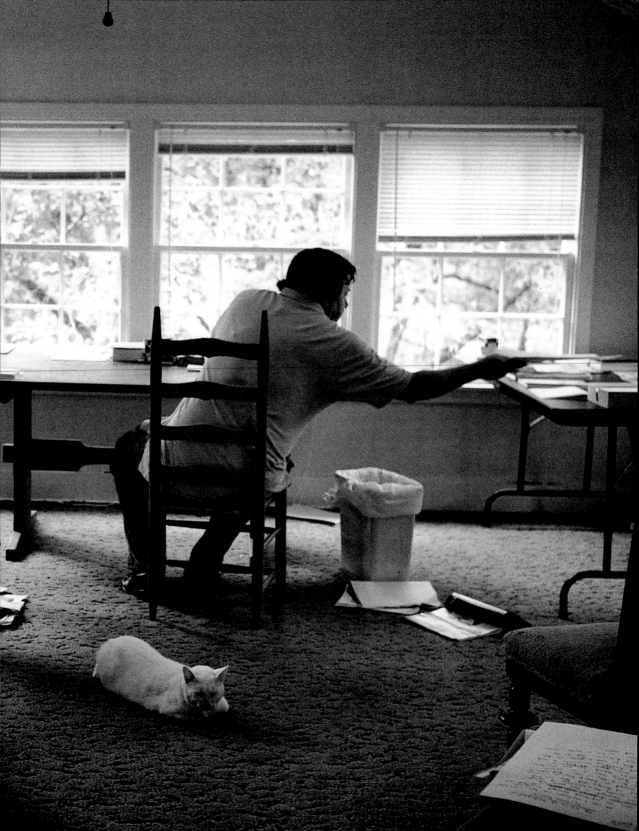

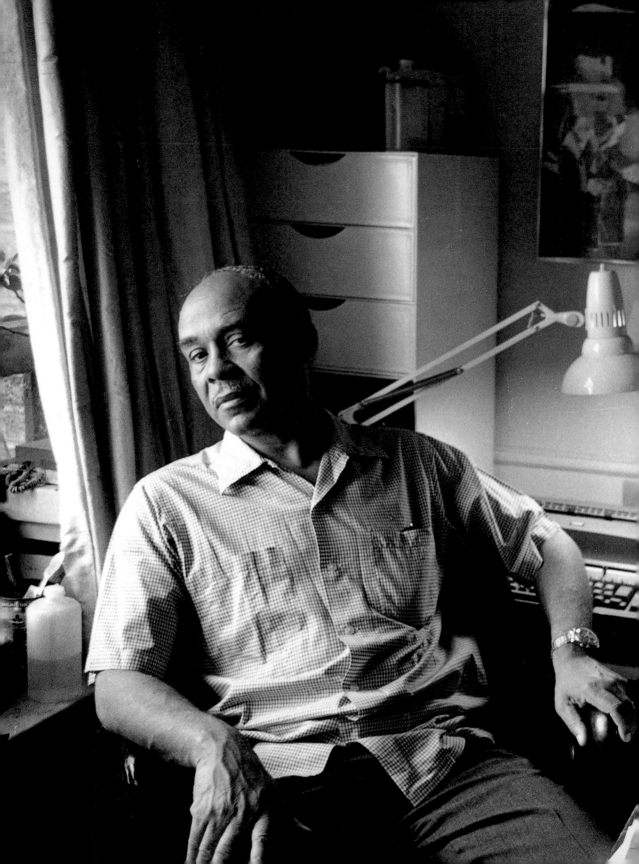

Ralph Ellison

I don't know; I think of myself as kind of lazy. Yet I do find that working slowly, which is the only way I seem able to work— although I write fast much of the time—the problem is one of being able to receive from my work that sense of tension and of high purpose being realized; that keeps me going. This is a crazy area that I don't understand— none of the Freudian explanations seems adequate.

I never know quite what has gone on in my subconscious in the night. I dream vividly, and all kinds of things happen; by morning they have fallen below the threshold again. But I like to feel that whatever takes place becomes active in some way in what I do at the typewriter. In other words, I believe that a human being's life is of a whole, and that he lives the full twenty-four hours. And if he is a writer or an artist, what happens during the night feeds back, in some way, into what he does consciously during the day. . . . Part of the pleasure of writing, as well as the pain, is involved in pouring into that thing which is being created all of what he cannot understand, cannot say, cannot deal with or cannot even admit in any other way.

43

Kurt Vonnegut

I just discovered a prayer for writers. I'd heard of prayers for sailors and kings and soldiers and so on—but never of a prayer for writers. . . . It was written by Samuel Johnson on April 3, 1753, the day he began work on the second volume of the first complete dictionary of the English language. He was praying for himself. . . . Anyway, this is the prayer: "O God, who hast hitherto supported me, enable me to proceed in this labour, and in the whole task of my present state; that when I shall render up, at the last day, an account of the talent committed to me, I may receive pardon, for the sake of Jesus Christ. Amen."

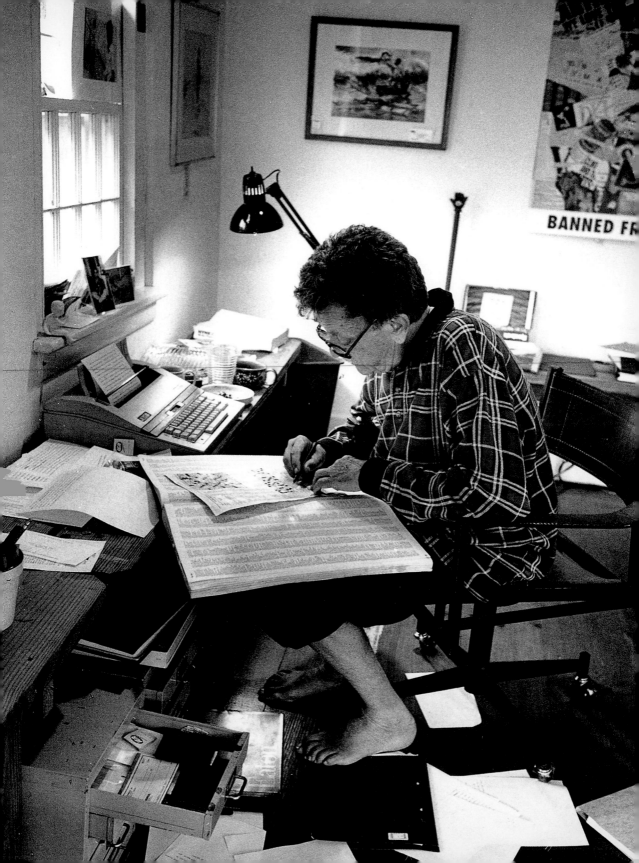

Anthony Powell

I really always, whenever I could, have worked all the morning. But in my early days I would quite often sit in front of a typewriter the whole morning without producing anything at all—it was not at all uncommon. Latterly I've got much more control as regards producing something, but one pays for that by not being able to do it later in the day. When I was younger I found I could usually work all morning and then again after tea for an hour or so. But now I find that any serious work has got to be done in the morning, that I really am pretty well out for what you might call inventing anything after that. . . .

The trouble about living in London is that you are an absolute martyr to the telephone if you work in the morning. . . . I do know people with strong enough nerves to take their receiver off or just let it ring, but my nerves have never been up to that. And what used to happen in practice was the telephone went and you answered it and it was a friend and before you know what the whole morning was gone.

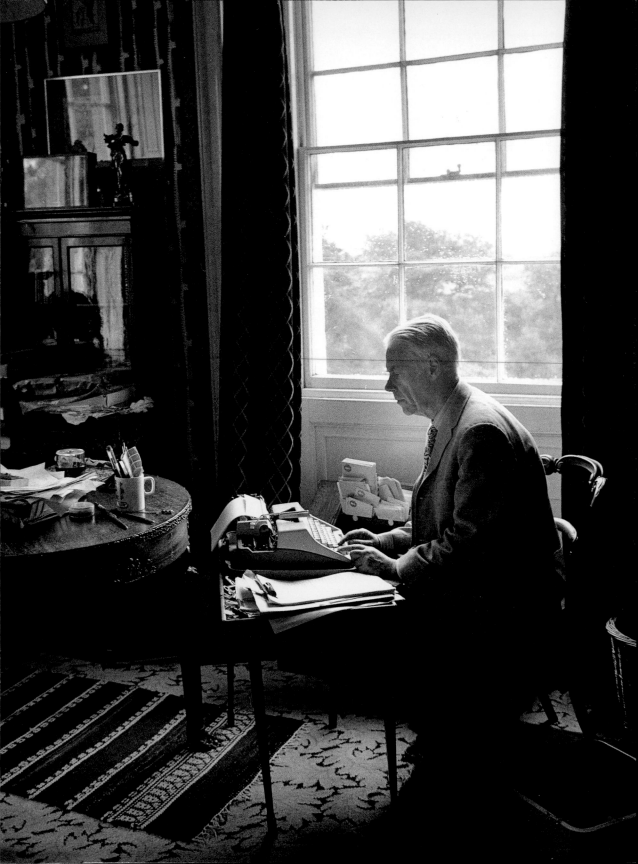

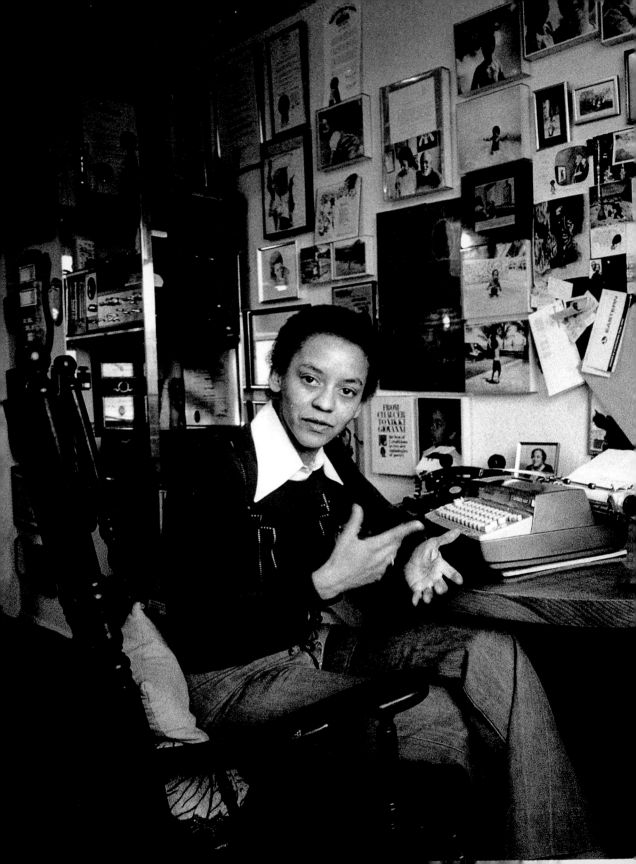

Nikki Giovanni

A poem is a way of capturing a moment. I don't do a lot of revisions because I think if you have to do that then you've got problems with the poem. Rather than polish the words, I take the time to polish the poem. If that means I start at the top a dozen times, that's what I do. A poem's got to be a single stroke, and I make it the best I can because it's going to live. . . .

I do get a thrill seeing my poems, and I will take the time for them. But if after a year I was working on a poem, not a book but a poem, I would say something's wrong with either the poem or me. That's probably not the best way to be a writer. I wouldn't even want to consider myself an example. I'm essentially undiscipined. I do a lot of thinking, a lot of reading, but I wouldn't recommend my writing method. . . . I don't have time to sit there and write for two hours whether I have something to say or not. I write when it's compelling.

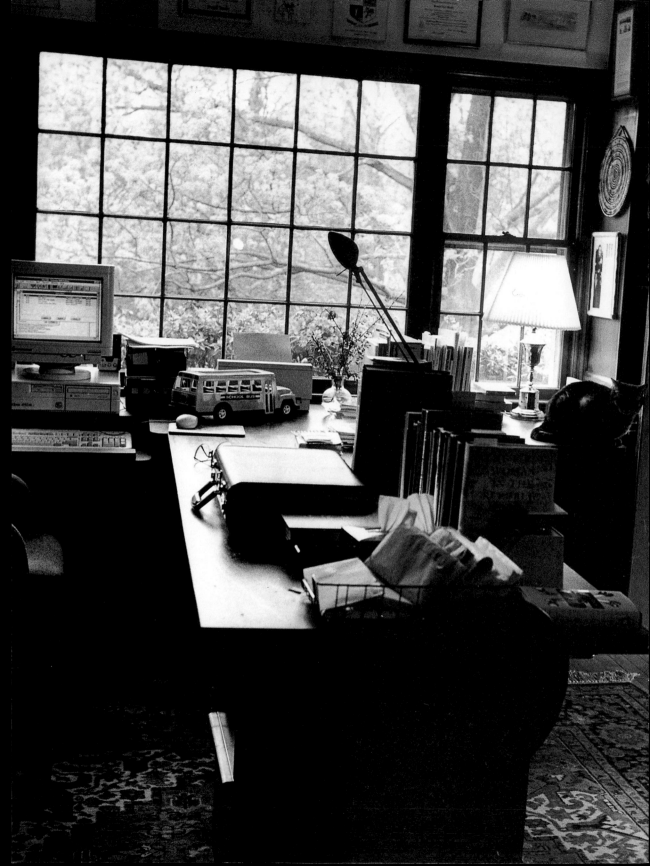

Russell Banks

I grew up suspicious of language, suspicious of storytelling. I was raised in New England, in a Protestant, restrained, and reticent family which had a good many taboos, not in terms of their behavior but in terms of their linguistic expression—the description of that behavior. . . . And that kind of ambivalence about storytelling I've maintained into my adult life.

So I've devised various means of overcoming this psychological disability . . . this compulsion to go silent and simply observe from outside and not comment, not describe, and not articulate in any way what I'm feeling or what I'm seeing, and that occurs in this most mechanistic way. I change the technical means by which I speak and shift back down to writing by hand with a fountain pen on lined paper. And when that doesn't work, I'll shift the medium and move to a regular typewriter. . . . The computer is the most liberating because it is the fastest: I can sneak up on myself and write things that I would never dare to say or write if I had to write it out longhand or if I had to say it publicly.

Peter Matthiessen

I am not really conscious of the reader. That's not arrogance, it's just that I don't think that way. You do your best work when you're not conscious of yourself. That's what's so exhilarating about it—you're out of your self.

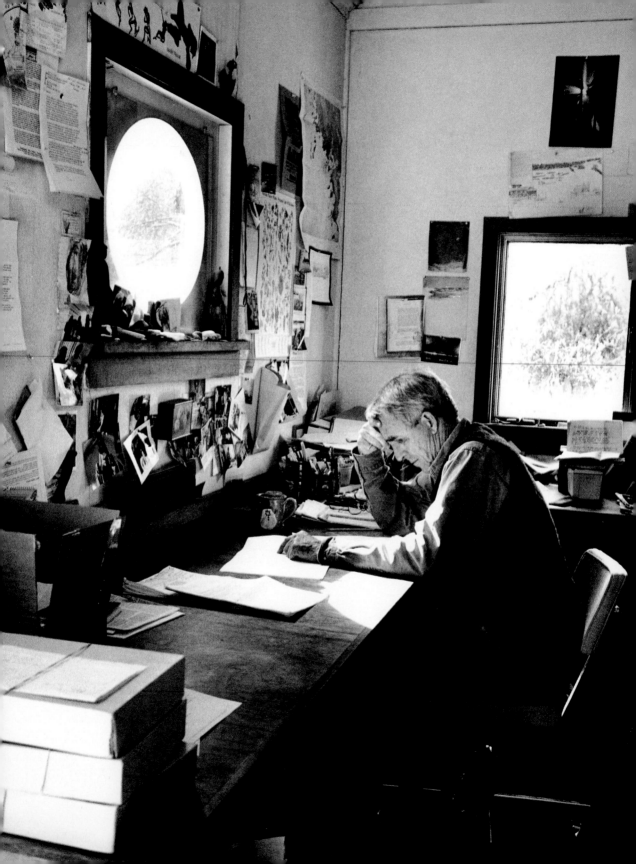

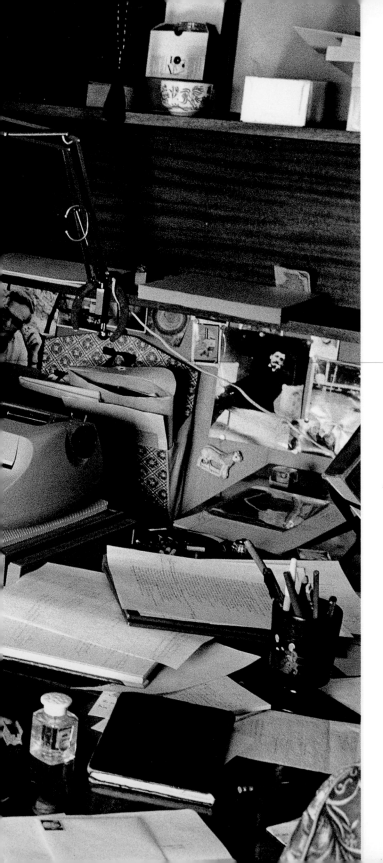

James Merrill

Whether you're at your desk or not when a poem's under way, isn't there that constant eddy in your mind? If it's strong enough all sorts of random flotsam gets drawn into it, how selectively it's hopeless to decide at the time. I try to break off, get away from the page, into the kitchen for a spell of mixing and marinating which gives the words a chance to sort themselves out behind my back. But there's really no escape, except perhaps the third drink.

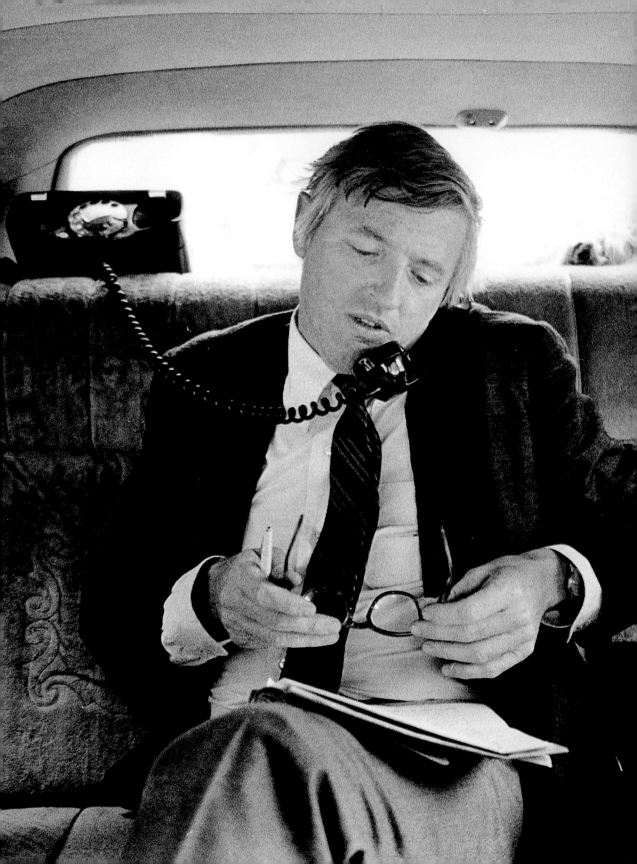

William F. Buckley, Jr.

It is a large car. I remember having no exact figure in mind when the manager of the garage in Texarkana asked me how long I wanted it, so I simply extended my legs from the desk chair I was sitting in and suggested it be two feet longer than the current standard model. . . .

I use the car constantly. . . . I turn on my Dictaphone, and check to see that the battery is alive. It is. It always is. Dictaphone has managed to construct a portable recording machine which is about the only thing around to remind us that we actually won the war against Japan.

Robert Penn Warren

You can't research to get a book. You stumble on it, or hope to. Maybe you will, if you live right.

The hard thing, the objective thing, has to be done before the book is written. And if anybody dreams up "Kubla Khan," it's going to be Coleridge. If the work is done the dream will come to the man who's ready for that particular dream; it's not going to come just from dreaming in general. After a thing is done, then I try to get tough and critical with myself. But damn it, it may sometimes be too late. But that is the fate of man.

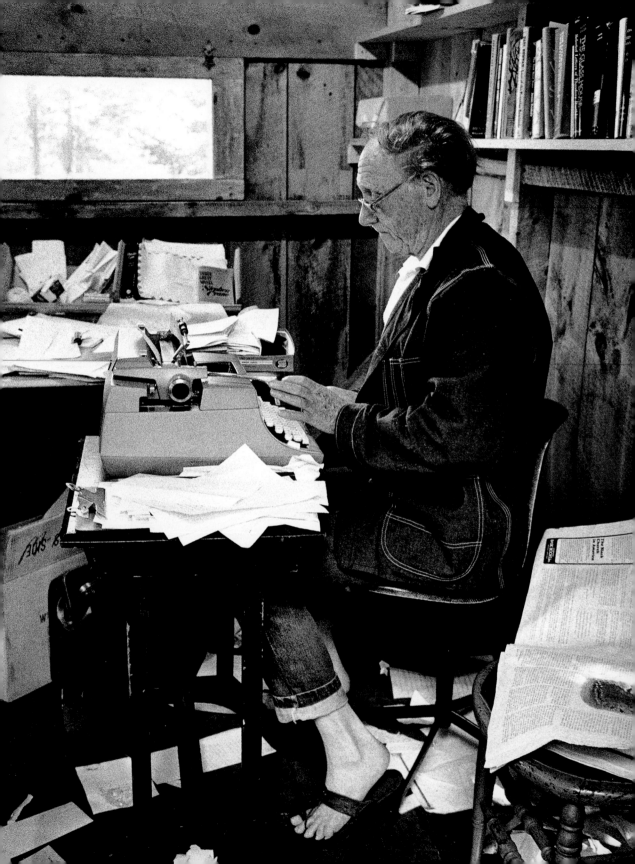

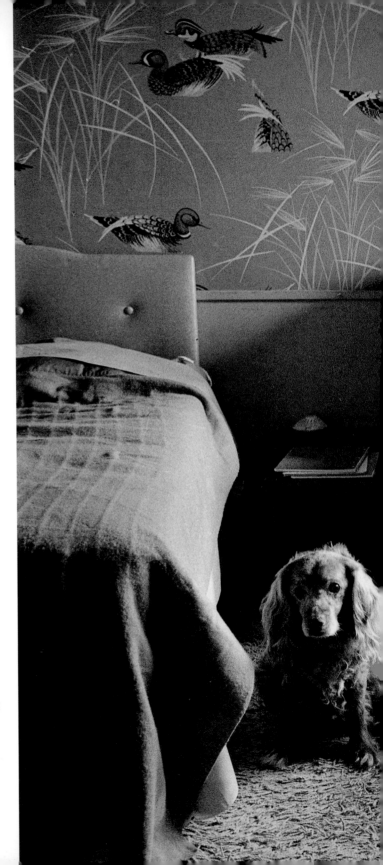

Ross Macdonald

Writing is about 75 percent a good memory for people, and not words. Memory is the factor in any novelist's work. . . . While completing one book, I let the others simmer. I keep on changing the plot. I might stick with the main outline—who kills whom—but almost everything else is likely to change. I fill notebooks with ideas, and I may take six to eight months writing about a situation that interests me. My ideas get better as time goes on.

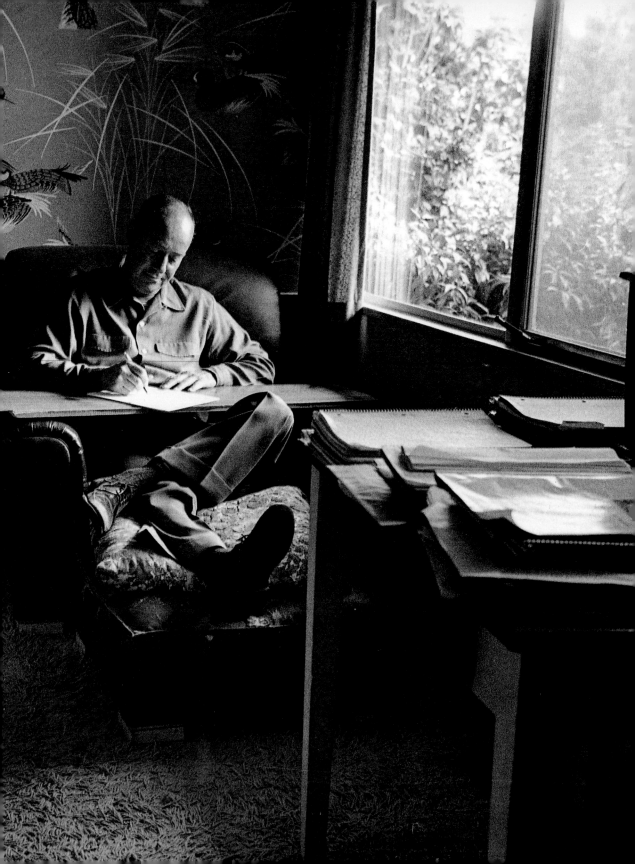

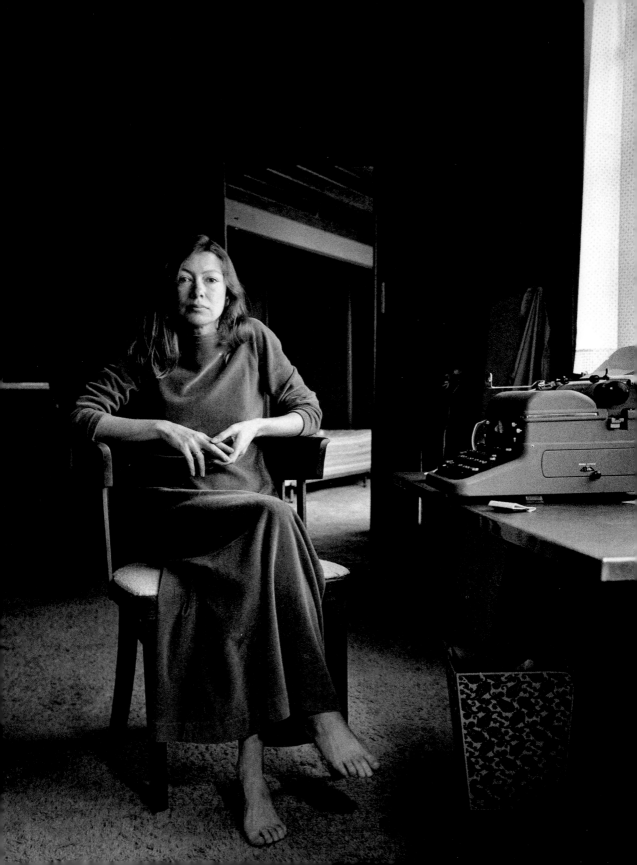

Joan Didion

I need an hour alone before dinner, with a drink, to go over what I've done that day. I can't do it late in the afternoon because I'm too close to it. Also the drink helps. It removes me from the pages. So I spend this hour taking things out and putting other things in. Then I start the next day by redoing all of what I did the day before, following these evening notes. When I'm really working I don't like to go out or have anybody to dinner, because then I lose the hour. If I don't have the hour, and start the next day with just some bad pages and nowhere to go, I'm in low spirits.

Another thing I need to do, when I'm near the end of the book, is sleep in the same room with it. . . . Somehow the book doesn't leave you when you're asleep right next to it.

William Maxwell

I like to work in my bathrobe
and pajamas, after breakfast,
until I suddenly perceive, from
what's on the page in the type-
writer, that I've lost my judg-
ment. And then I stop. It's usu-
ally about twelve-thirty. But I
hate getting dressed. The clean-
ing woman, who may not
approve of it, though she's never
said, my family, the elevator men,
the delivery boy from Gristede's—
all of them are used to seeing me
in this unkempt condition. What
it means to me is probably sym-
bolic—you can have me after
I've got my trousers on, but not
before. When I retired from *The
New Yorker* they offered me an
office, which was very generous
of them because they're shy on
space, but I thought, What
would I do with an office at *The
New Yorker*? I would have to put
my trousers on and ride the sub-
way downtown to my type-
writer. No good.

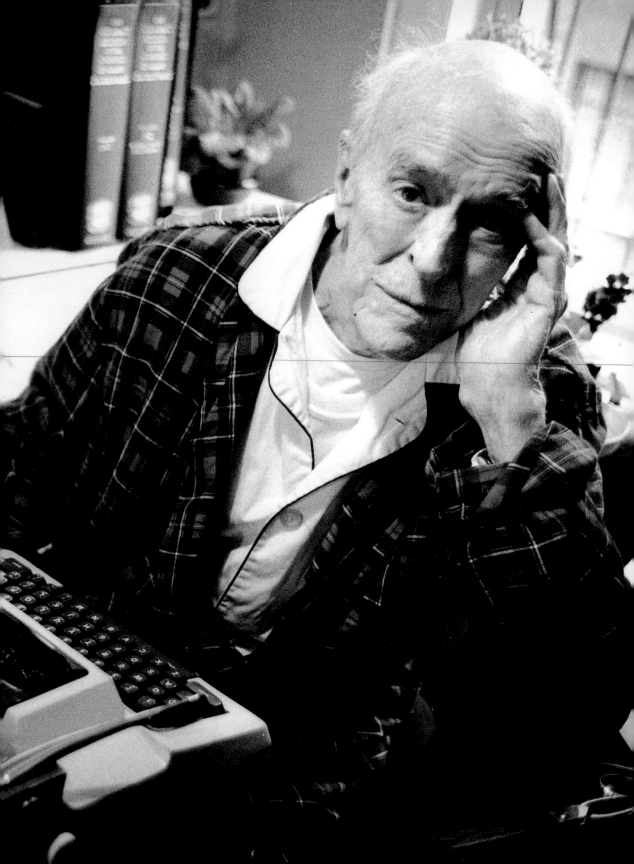

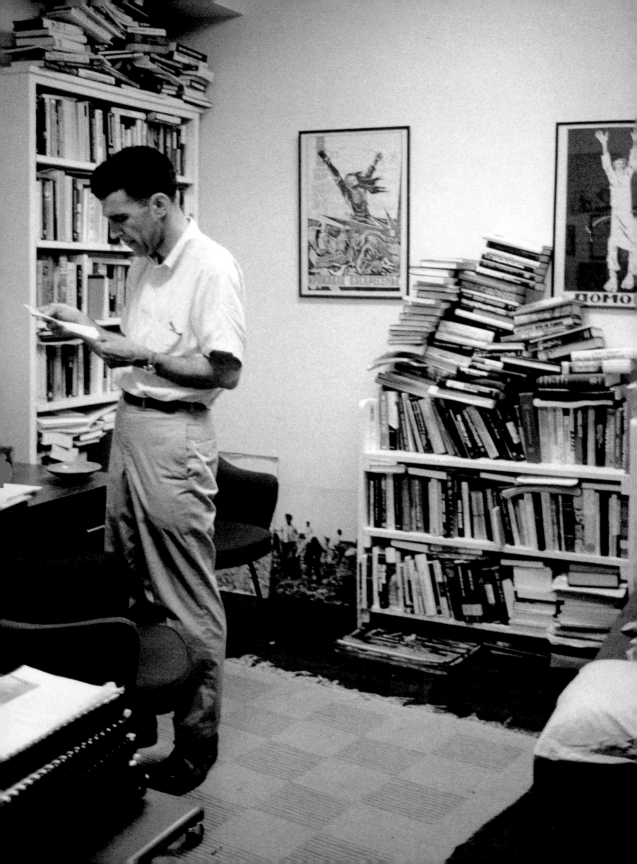

Robert Coles

I work always in the morning. I can only write in the morning, early. I don't pace, I just stare out of the window. I have a large window and I can see a field and some woods and a fence, a stone fence, and I stare. I also stare at pictures I have of Walker Percy and William Carlos Williams, because both of these physician-writers have meant so much to me. I've been privileged to know both of them. I look at their pictures and remember them, and think to myself, frankly, how lucky, lucky, lucky I've been to know these two people and to be able to call them friends, and to be able . . . to call upon them, literally, on the phone, or in visits, and call upon them in my mind.

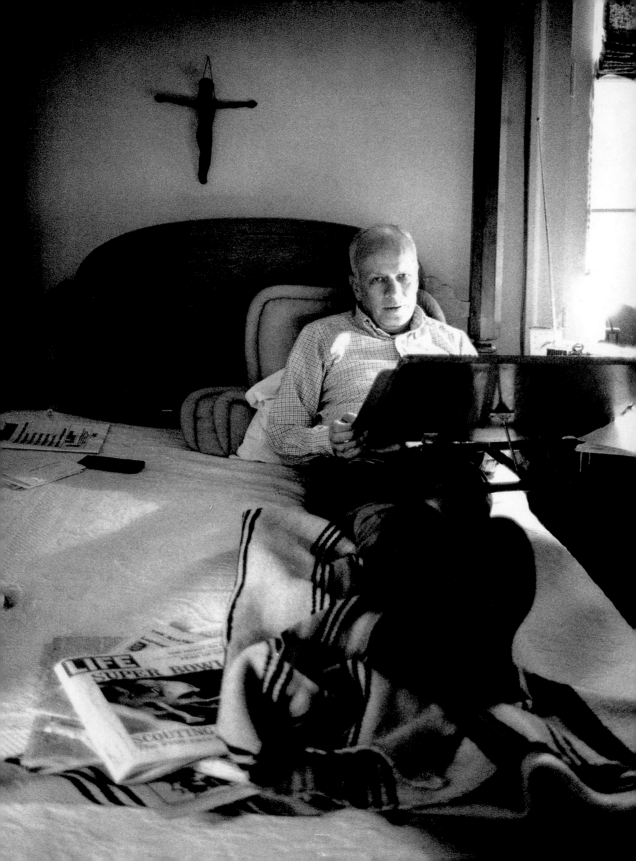

Walker Percy

The only thing I can say is that it takes place—or the best of it takes place—in a sort of vacuum. On the worst of mornings. On the least likely of mornings. When you expect nothing to happen. When the page is blank. When the mind is blank. Even in a state of depression or melancholia. And then, only with good luck. . . .

Oh, don't misunderstand me. I think you have to be sitting there. You have to "wait" in good faith. You have to go to work like anyone else, or I do anyway. I have to go to work at nine o'clock. And in that sense you force it. You've got to start in some way. . . . You have to have a routine and live up to it and then hope for the best.

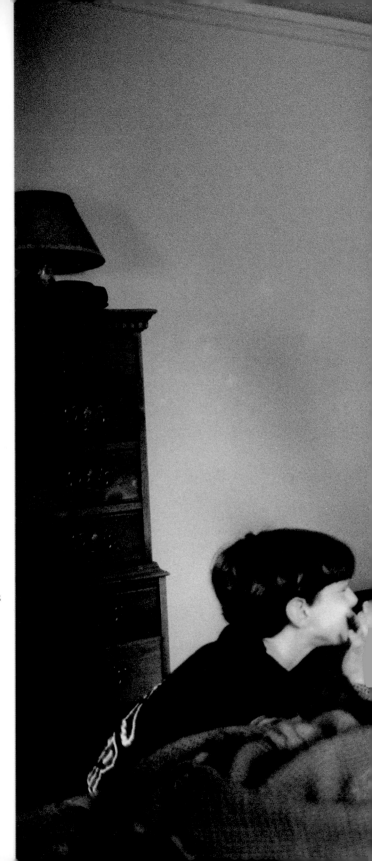

Cathleen Schine

I love my bed. It is larger than a
desk and better designed to hold
books and papers. It is softer than a
desk and better designed for naps. It is
the center of all good things. And,
day or night, everyone knows where
to find me.

Eugene Ionesco

I work in the morning. I sit comfortably in
an armchair. . . . I let characters and sym-
bols emerge from me, as if I were dream-
ing. I always use what remains of my
dreams of the night before. Dreams are
reality at its most profound, and what you
invent is truth because invention, by its
nature, can't be a lie. Writers who try to
prove something are unattractive to me,
because there is nothing to prove and
everything to imagine. So I let words and
images emerge from within. If you do that,
you might prove something in the process.

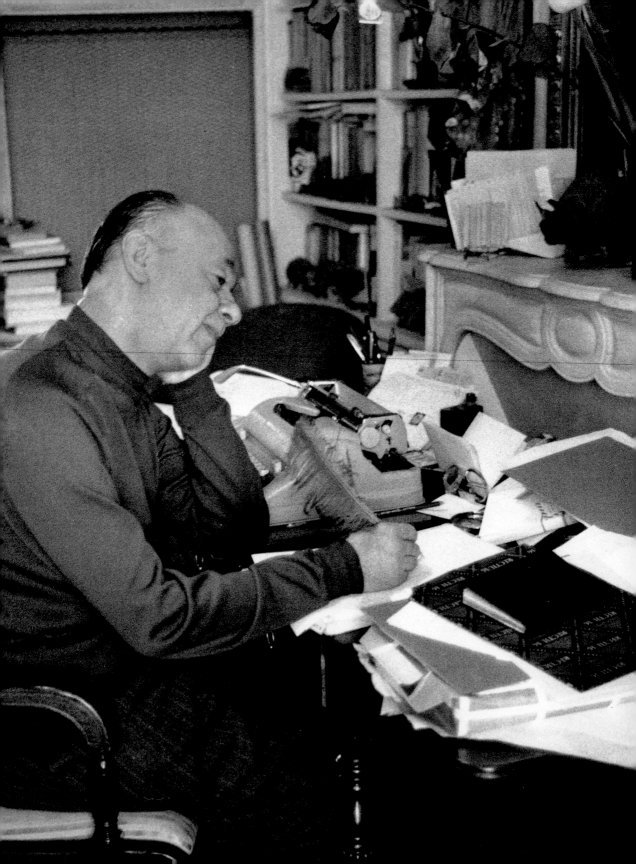

Roy Blount, Jr.

Why write, when you
can watch a movie on
your typewriter?

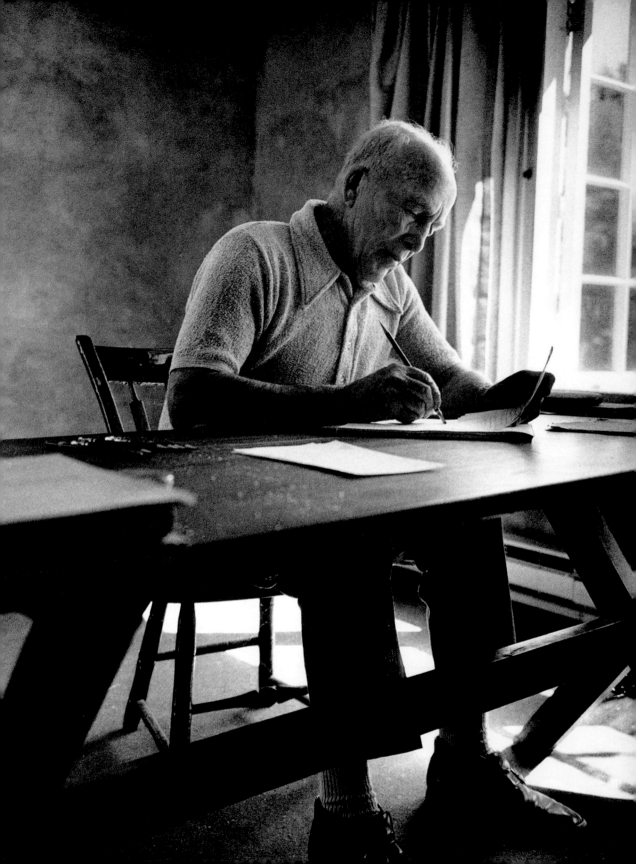

Archibald MacLeish

I am sure—I mean I am not sure at all but I believe—the master poets must come at their poems as a hawk on a pigeon in one dive. I can't. I chip away like a stonemason who has got it into his head that there is a pigeon in that block of marble. But there's a delight in the chipping. At least there's a delight in it when your hunch that the pigeon in there is stronger than you are carries you along. There is no straining then nor *are* you strained—all assurance and confidence. Oh, you can be fooled, of course—there may be nothing there but a stone.

Terry Southern

Faulkner always liked to say: "A writer without a bottle of whiskey is like a chicken without a goddam head." And Hemingway, of course, enjoyed nothing more than eulogizing the "Godly Brothers Gordon" for hours on end. Joyce would "knock back a whopper" at every opportunity. In fact, one would be hard pressed to name more than five writers of first account who were not drinkers. . . .

This is not to suggest that any of these writers were alcoholics. I don't believe that a serious writer is in danger of becoming an alcoholic, because, after a certain point, one would not be working *behind* it, but directly in front of it, at peril of getting wiped out blotto, thereby defeating its purpose—which is, after all, motivational and as a hedge against the desolation of such a lonely endeavor.

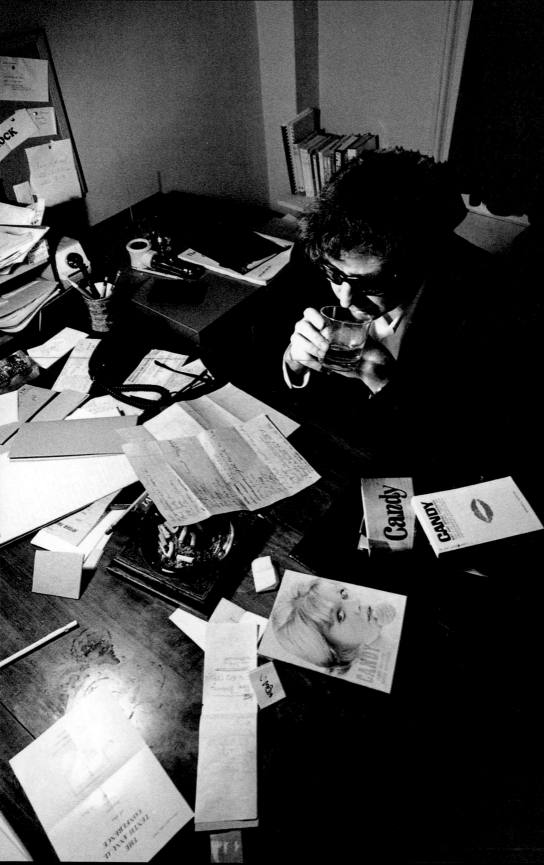

Eudora Welty

I'm one of the people who think best in the morning. I like to wake up ready to go, and to know that during that whole day the phone wouldn't ring, the doorbell wouldn't ring—even with good news— and that nobody would drop in. This all sounds so rude. But you know, things that just make a normally nice day are not what I want. I don't care what the weather is. I don't care what the temperature is. I don't care where I am or what room I'm in. I'd just get up and get my coffee and an ordinary breakfast and get to work. And just have that whole day! And at the end of the day, about five or six o'clock, I'd stop for good that day. And I'd have a drink, a bourbon and water, watch the evening news—*MacNeil/Lehrer News Hour*—and then I could do anything I wanted to.

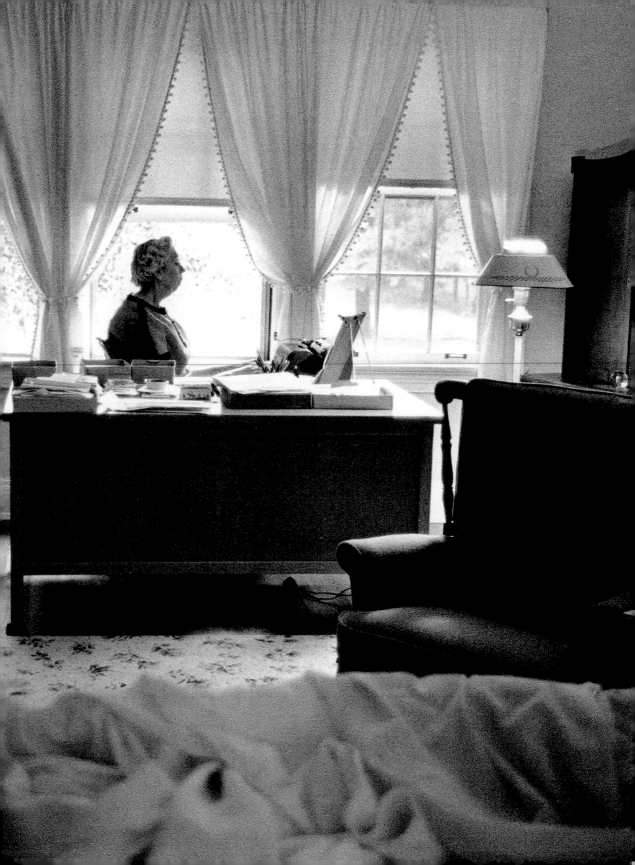

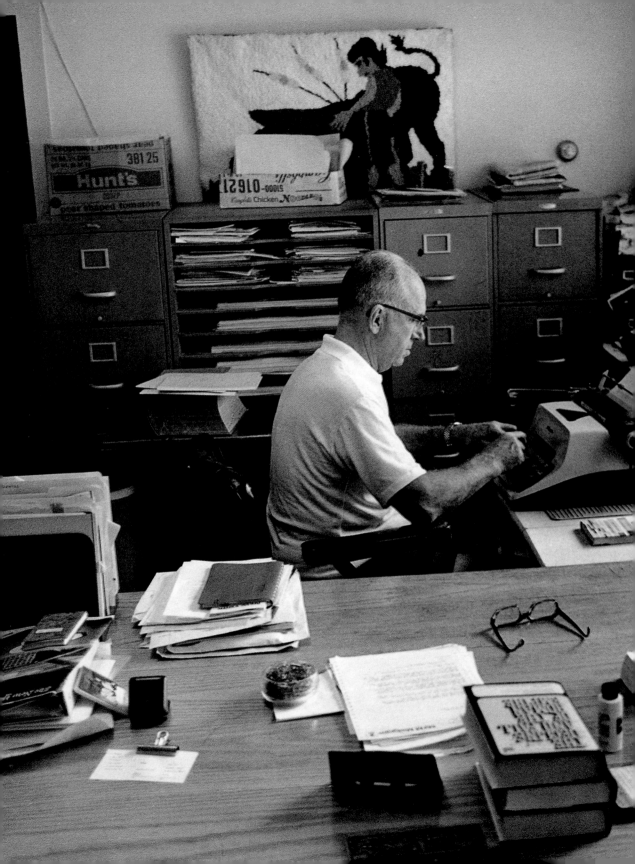

James A. Michener

When I am about to start a major
project, I am much like a zen master in
Japan who is about to serve a ritual tea.
I wash my face, cleanse my mind, eat
sparingly, exercise every evening by
taking long walks, go to bed early and
rise at seven to go to my typewriter. I
do this seven days a week for the two
years during which I am doing the
actual writing, and I am loath to
permit interruptions. In the morning I
do not welcome either visitors or
phone calls because writing is hard,
exhausting work, and at twelve-thirty
when I stop, I am usually sweaty.

I customarily wear loose Bermuda
shorts, very loose T-shirt or loose sport
shirt, loose socks and floppy sandals,
and I have grown to feel wonderfully
at ease in that uniform; it restricts me
at no point and leaves my arms and
hands free to move easily. I also wear
reading glasses with thick lenses, and I
work with such intensity that some-
times when I pause to look out the
window the world is a blur because
my focus has been at such close range
for so long.

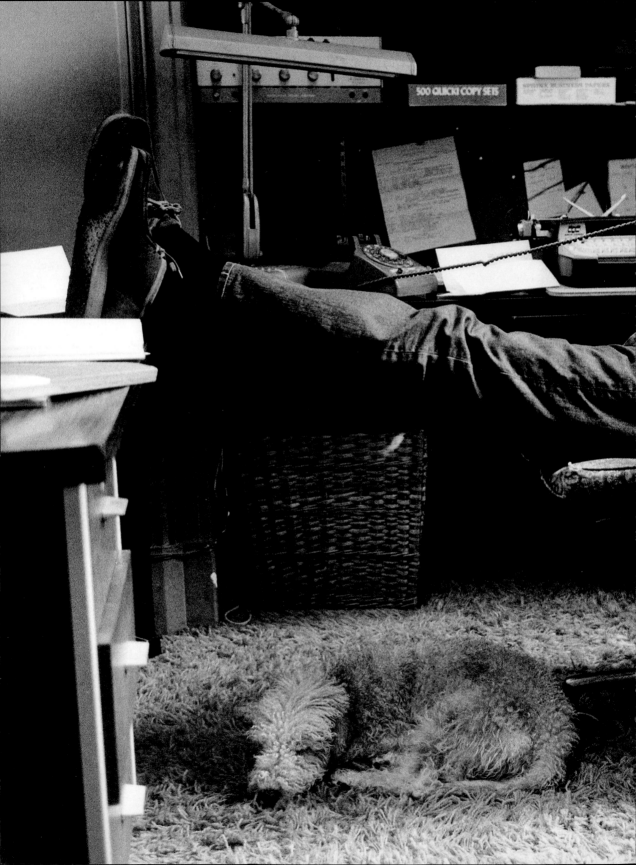

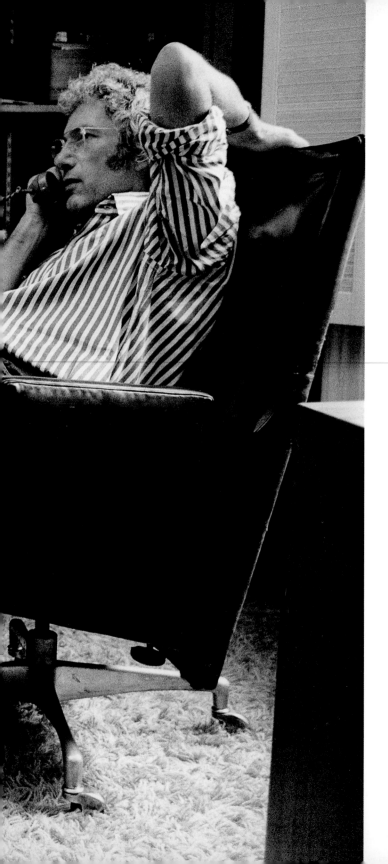

Joseph Heller

I have to be alone. A bus is good. Or walking the dog. Brushing my teeth is marvelous—it was especially so for *Catch-22*. Often when I am very tired, just before going to bed, while washing my face and brushing my teeth, my mind gets very clear . . . and produces a line for the next day's work, or some idea way ahead. I don't get my best ideas while actually writing.

Rita Dove

What I love about my cabin—what I always forget that I love until I open the door and step into it—is the absolute quiet. Oh, not the dead silence of a studio. A silence so physical that you begin to gasp for air; and it's not the allegorical silence of an empty apartment, with its creaks and sniffles and traffic a dull roar below, and the neighbors' muffled treading overhead. No, this is the silence of the world: birds shifting weight on branches, the branches squeaking against other twigs, the deer *hooosching* through the woods. . . . It's a silence where you can hear your blood in your chest, if you choose to listen.

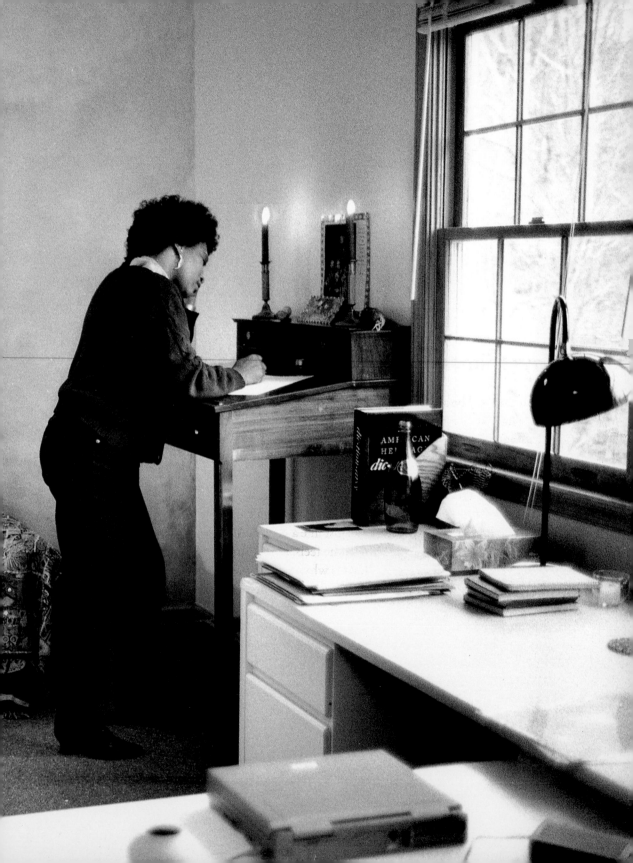

Georges Simenon

The beginning will be always the same; it is almost a geometrical problem: I have such a man, such a woman, in such surroundings. What can happen to them to oblige them to go to their limit? . . . On the eve of the first day I know what will happen in the first chapter. Then, day after day, chapter after chapter, I find what comes later. After I have started a novel I write a chapter each day, without ever missing a day. . . . I don't see anybody, I don't speak to anybody, I don't take a phone call—I live just like a monk. All the day I am one of my characters. I feel what he feels. . . . It's almost unbearable after five or six days. . . . That is why, before I start a novel—this may sound foolish here, but it is the truth—generally a few days before the start of a novel I look to see that I don't have any appointments for eleven days. Then I call the doctor. He takes my blood pressure, he checks everything. And he says, "Okay." . . . I have to be sure that I am good for the eleven days.

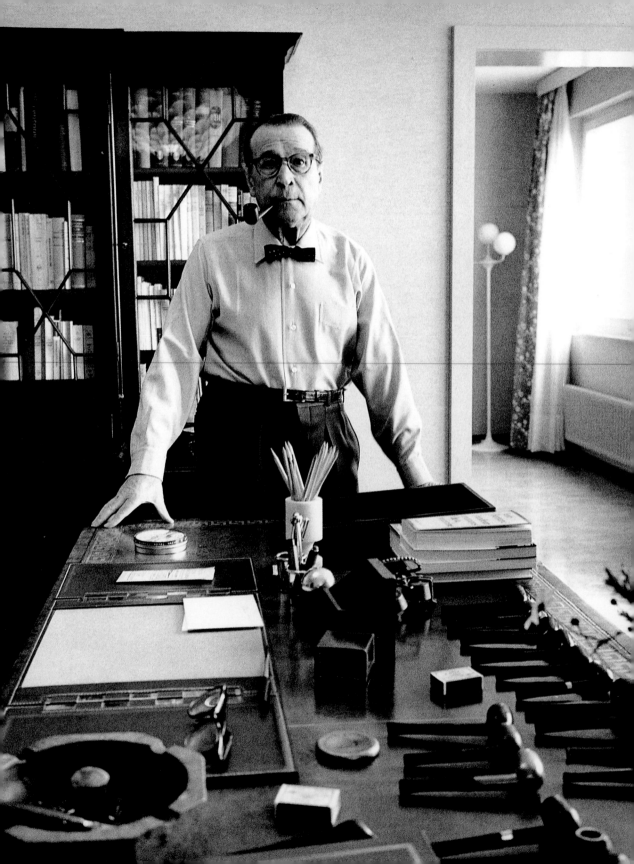

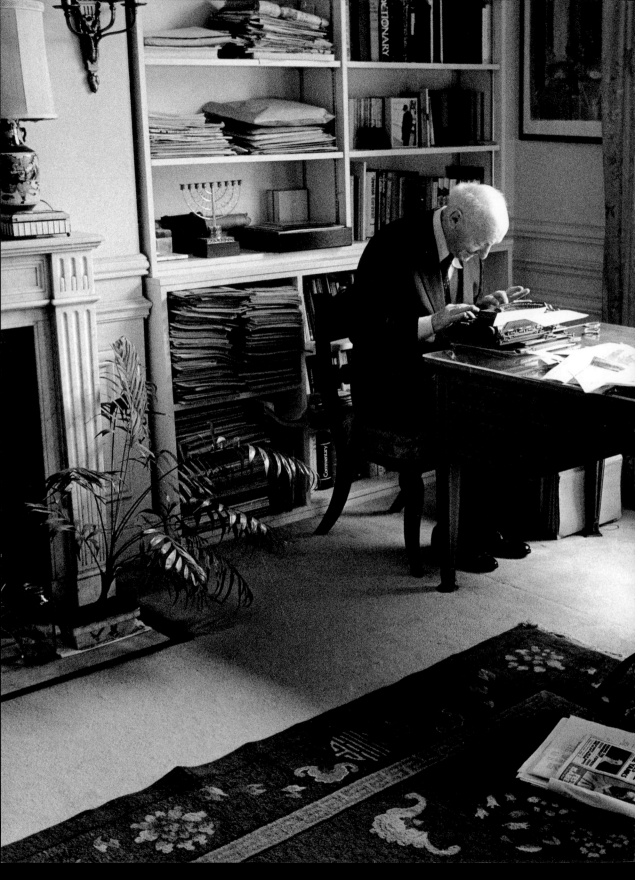

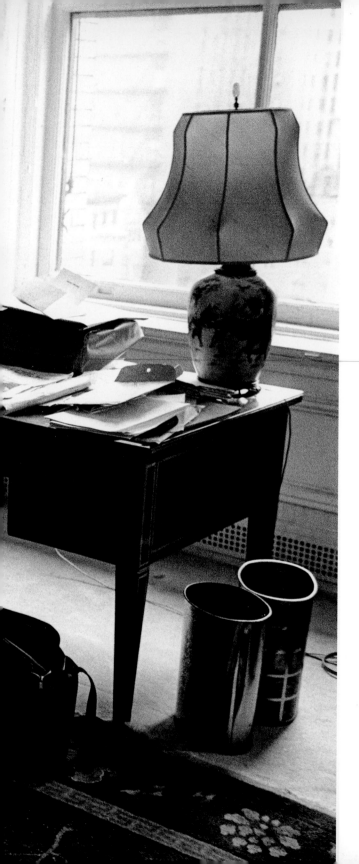

Isaac Bashevis Singer

When I get up in the morning, I always have the desire to sit down to write. And most of the days I *do* write something. But then I get telephone calls, and sometimes I have to write an article for *The Forward.* And once in a while I have to write a review, and I am interviewed, and I am all the time interrupted. Somehow I manage to keep on writing. I don't have to run away. Some writers say that they can only write if they go to a far island. They would go to the moon to write not to be disturbed. I think that being disturbed is a part of human life and sometimes it's useful to be disturbed because you interrupt your writing and while you rest, while you are busy with something else, your perspective changes or the horizon widens. All I can say about myself is that I have never really written in peace.

Mona Simpson

I work paragraph to paragraph, or even line to line. I started out as a poet. I move at the pace of a poet, that's for sure. I'm certainly slow. I have an emotional sense of where things are going to, but I don't do a whole chart or anything like that. . . .

I'm a real believer in research, but I have a funny way of doing it. I think you should write first and *then* do the research.

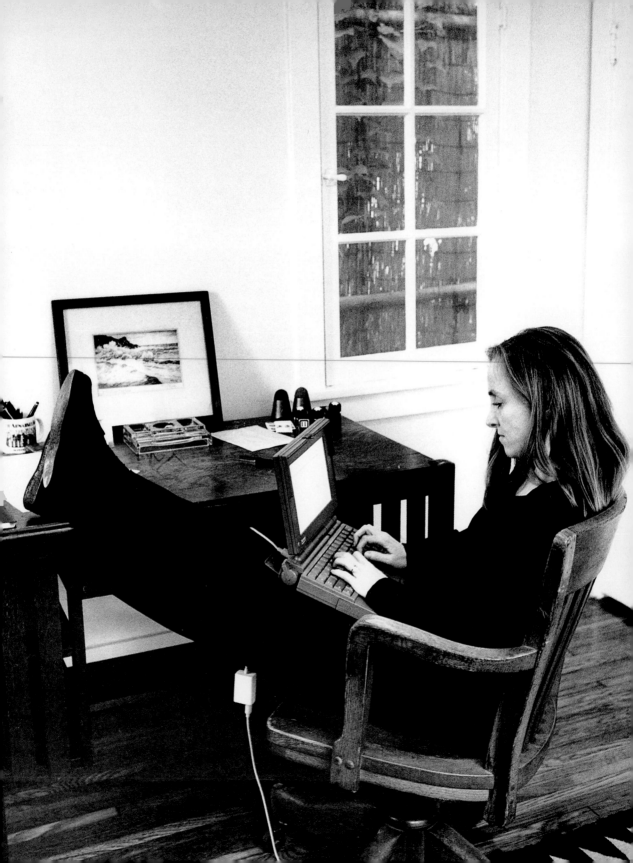

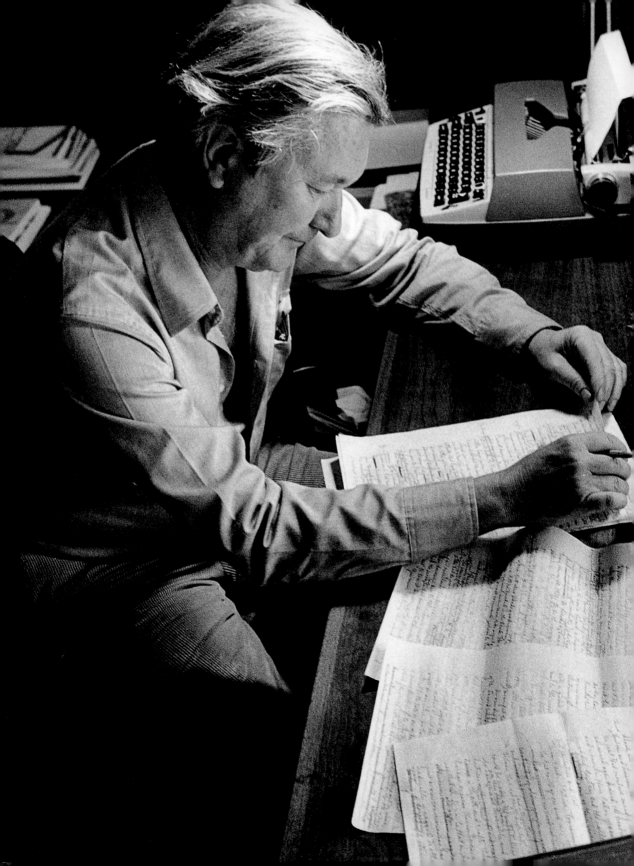

William Styron

I've never written any prose fiction
on the typewriter. I've just always
had a very comfortable relation-
ship with No. 2 pencils and these
yellow sheets, which I might add
vary also in quality. Some you get
are abominable: you can't erase on
them, which is something that I
like to do. I would be almost in
deep despair if I found myself on
some island on vacation and
unable to get yellow sheets. I *could*
compose on white sheets, in long-
hand, but it would be an added
handicap. . . .

I get a fine warm feeling when
I'm doing well, but that pleasure is
pretty much negated by the pain of
getting started each day. Let's face
it, writing is hell.

Tennessee Williams

In Key West I get up just before daybreak, as a rule. I like being completely alone in the house in the kitchen when I have my coffee and ruminate on what I'm going to work on. I usually have two or three pieces of work going at the same time, and then I decide which to work on that day.

I go to my studio. I usually have some wine there. And then I carefully go over what I wrote the day before. You see, baby, after a glass or two of wine I'm inclined to extravagance. I'm inclined to excesses because I drink while I'm writing, so I'll blue pencil a lot the next day. Then I sit down, and I begin to write.

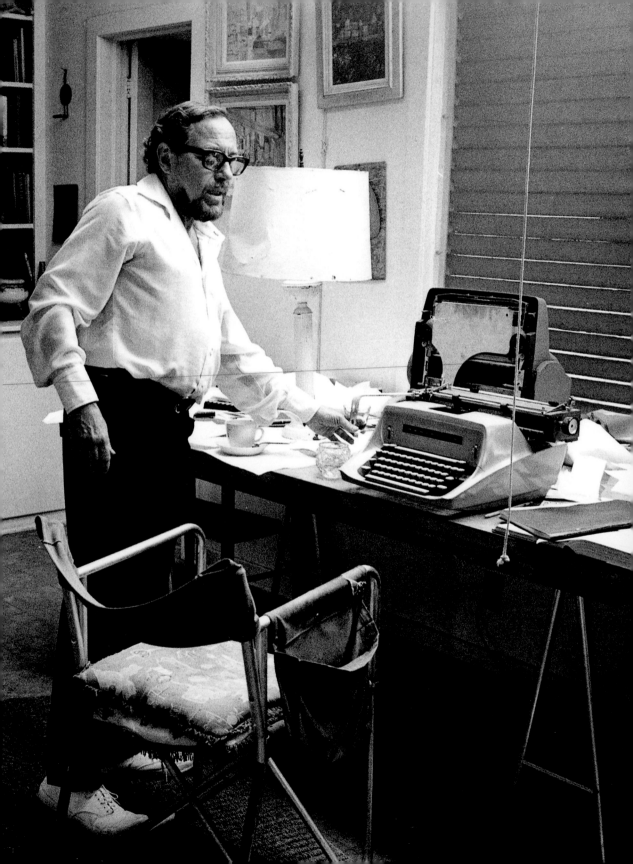

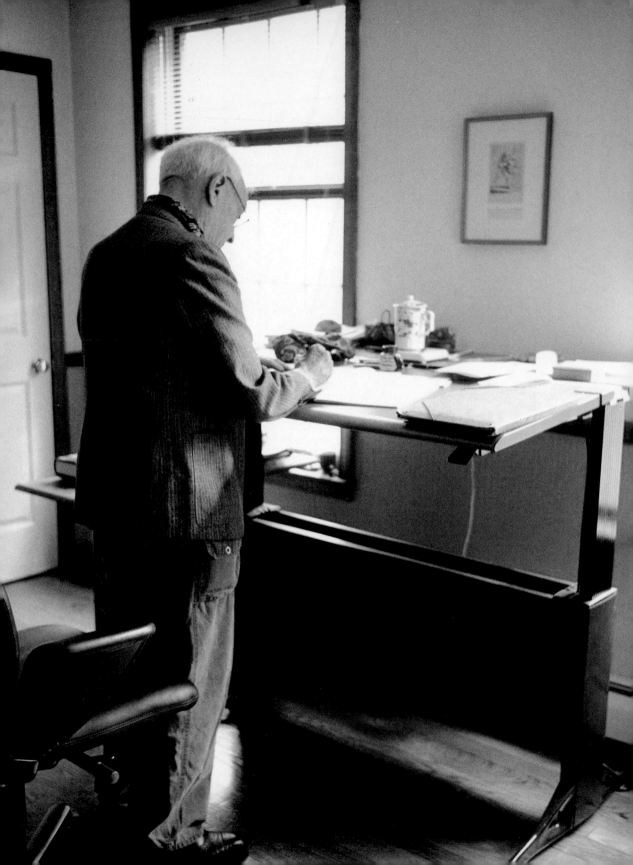

Saul Bellow

I feel that art has something to do with the achievement of still-
ness in the midst of chaos. A stillness which characterizes prayer,
too, and the eye of the storm. I think that art has something to do
with an arrest of attention in the midst of distraction.

Ann Petry

It doesn't much matter where I sit to write. The first draft is in my head. The next draft is in longhand on paper, and after that, I type it. All along the way I make changes. The final draft bears very little resemblance to whatever it was I had in my head.

How many years have I been writing? Oh, let me see. I was in high school and if I remember correctly we had been reading *A Tale of Two Cities*. Our teacher asked us to write an imaginary scene from the novel and, two or three days later, she read my piece out loud. She said, "I honestly believe that, if you really wanted to, you could become a writer."

I worked in my family's two drugstores after I went to pharmacy school, and I used to write whenever I had a spare moment. I was always getting rejection slips. My aunt would pick up the mail and come by and hand me the envelope saying, "Here's another one." Not what I'd call encouragement.

I was married and living in New York when I had my first story published in *The Afro-American*—a weekly newspaper that came out in Baltimore. I was thrilled. . . . I wrote another and it was published in a magazine put out by the NAACP called *The Crisis.* Someone from Houghton Mifflin read it and asked if I would be interested in writing a novel and applying for a Houghton Mifflin fellowship. I said that I wasn't writing a novel but that in another year I might be. They wrote again in the following year and asked if I was ready. The application asked for five chapters and a synopsis. In two or three months they wrote saying they would like to meet me. I thought they were going to give me my manuscript back, but they said they wanted to publish it. *The Street* was published in 1946.

I believed that if I lifted my arms up I could fly.

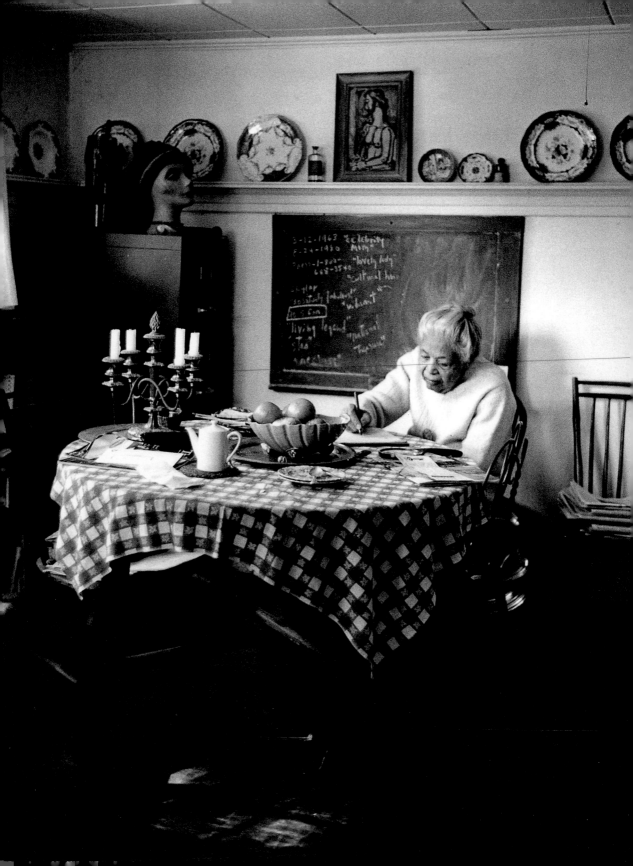

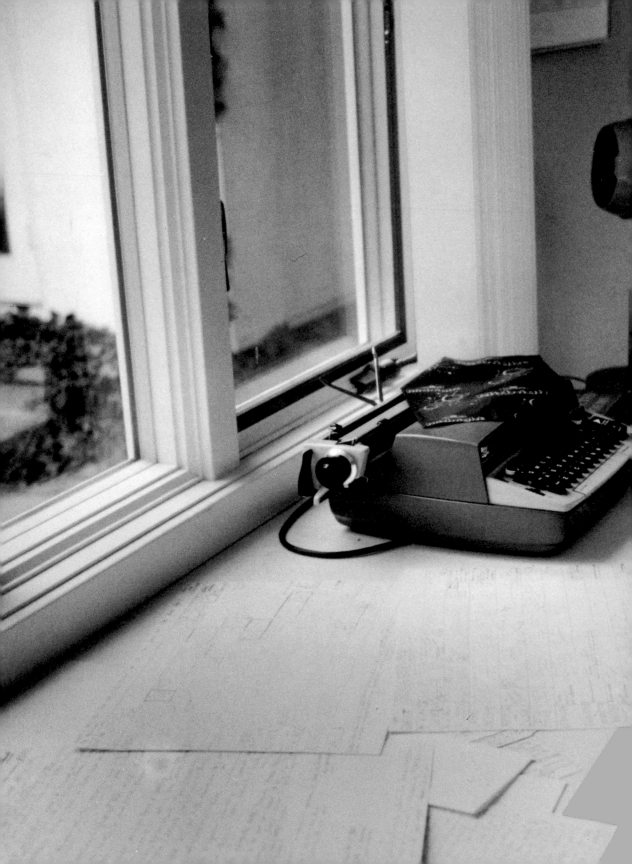

Joyce Carol Oates

I don't have any formal writing habits. Most of the time I do nothing, and the fact of time passing so relentlessly is a source of anguish to me. There are not enough hours in the day. Yet I waste most of my time, in daydreaming, in drawing faces on pieces of paper. . . .

When I'm with people I often fall into a kind of waking sleep, a daydreaming about the people, the strangers, who are to be the "characters" in a story or a novel I will be writing. . . . At times my head seems crowded; there is a kind of pressure inside it, almost a frightening physical sense of confusion, fullness, dizziness. Strange people appear in my thoughts and define themselves slowly to me: first their faces, then their personalities and quirks and personal histories, then their relationships to other people, who very slowly appear. . . . I try to put this all together, working very slowly, never hurrying the process. I can't hurry it any more than I can prevent it.

Veronica Chambers

It's no accident that so far, I've lived on the top floor of three walk-up buildings in Brooklyn. A friend of mine once compared me to a cat, saying I like to climb up high and feel like I'm the queen of all I survey. I often felt like that when I was writing *Mama's Girl*—I needed somehow to find a place, a perch that was high enough so I could look at this incredibly painful history with my family, especially my mother, and write about it. I was afraid of digging too deep, that somehow I could lose myself in all the hurt—like so much quicksand. So I would find high places to curl up in like a cat—the loft in my apartment, the roof of my brownstone, even the kitchen counter.

There's a scene in Zora Neale Hurston's *Their Eyes Were Watching God* when Janie and Tea Cake are down South and there's a hurricane and a flood—natural disaster of almost biblical proportions—and they are desperately looking for something to grab onto—a piece of wood, an old tire to climb up on and keep from drowning. Like so many people, throughout my childhood, books were the things that kept me from drowning. In the midst of all the poverty and violence, the *unnatural* disasters of inner-city living, books saved me. And while I try not to take myself too seriously, I take my work seriously. Because I know the power of words, I know the good they can do.

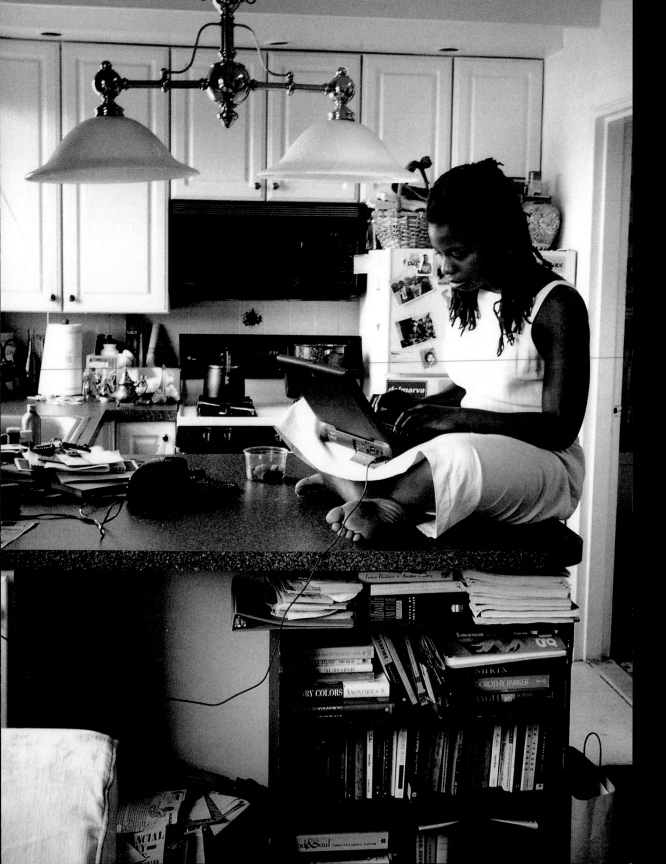

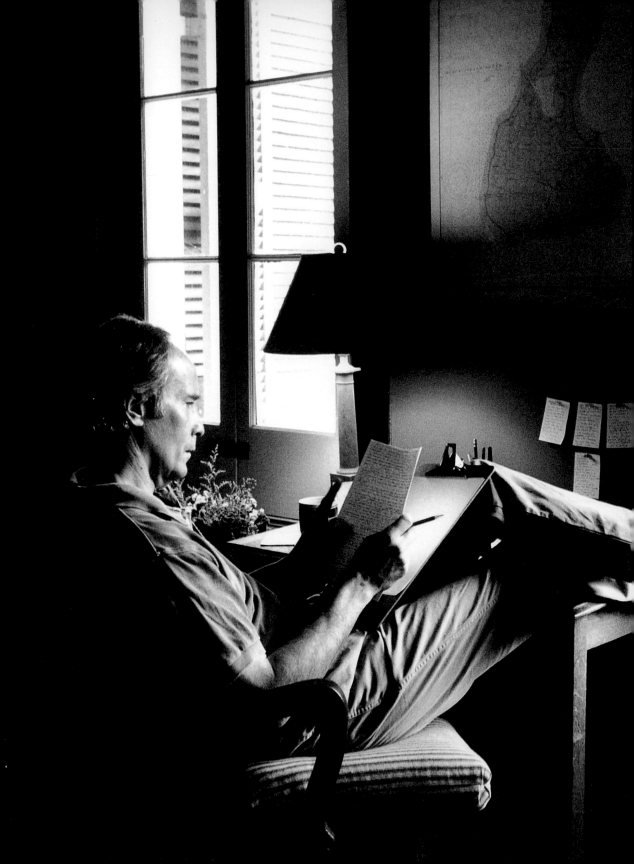

Richard Ford

My "desk" is more of a concept than a thing. It's like the "Belize desk" at the State Department; an idea more than a place you actually sit at. "Ford's writing at his desk." That could mean a lot of things. It could mean on an airplane or a Greyhound bus, or in a rental car or a rented house. It could mean in the Hotel L'Abbaye (though it would *not* mean at an outside table at the Deux Magots). Like Emerson's giant, I carry my desk with me.

Naturally, it could simply mean a desk, too. I have three or four, accumulated over the years. I could never live with only one, or with one "writing room," for that matter—my attention being in a constant deficit for change and variety. A thirst for new surfaces. My desk in this picture is a child's desk, bought out of a grammar school in Two Dot, Montana, or some such place, by a lady I once rented a house from in Lolo. It's made of thick fir, and I can guarantee you it's as heavy as a small piano and twice as sturdy.

Edmund White

I write in longhand, and I write in very beautiful notebooks and with very beautiful pens.... If I write a page a day, I'm lucky. But I write less.... It's a very uncomfortable process; I don't like it at all.

Writers say two things that strike me as nonsense. One is that you must follow an absolute schedule every day. If you're not writing well, why continue it? I just don't think this grinding away is useful. The other thing they say: I write because I must. Well, I have never felt that, and I doubt most of them do either. I think they are mouthing a cliché. I don't think most people write because they must; perhaps economically they must, but spiritually? I wonder.

I wish I were more at home with writing. I can go a year or two or three without picking up my pen and I'm perfectly content. The minute I have to write I become neurotic and grouchy and ill; I become like a little wet, drenched bird, and I put a blanket over my shoulders and I try to write and I hate myself and I hate what I'm writing. Writing depends upon a fairly quiet life, whereas I am a sociable person. I think every writer goes back and forth on this question; it's a constant struggle to find the right balance between solitude and society and I don't think anyone ever does. I find it reassuring to read the complaints of Chekhov: "My country house is full of people, they never leave me alone; if only they would go away I could be a good writer." He's writing this close to the end of his life.

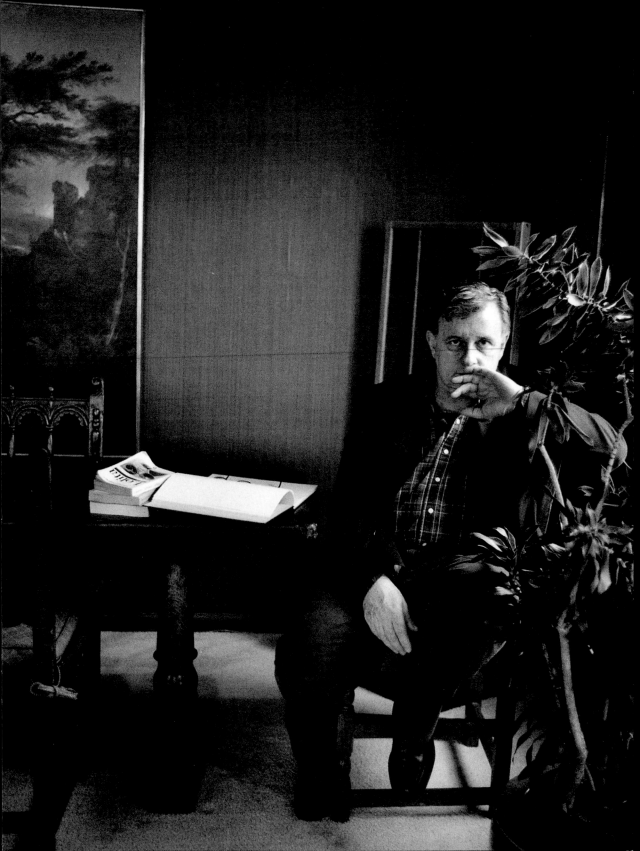

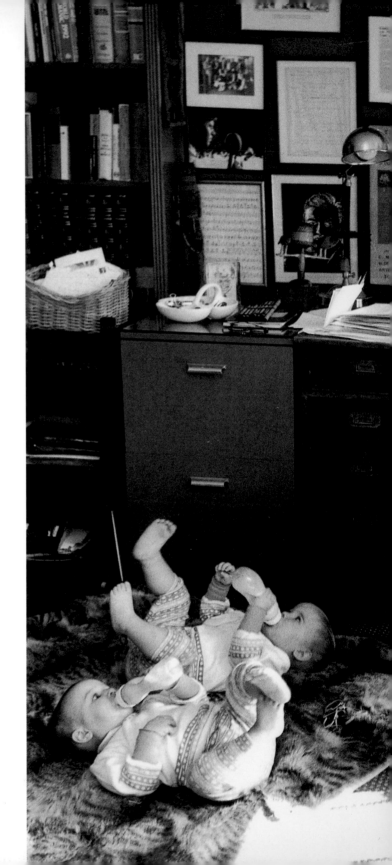

George Plimpton

I suspect I sit at entirely the wrong desk. It is so crowded with distractions that there's hardly room to set a small pad amongst them and get to work—framed photos, mementos, trophy cups full of unsharpened pencils, a box of foreign currency, a tin in the form of Shea Stadium with a top that when removed plays "Take Me Out to the Ballgame," a Masai doll, a tined musical instrument from West Africa, a brass megaphone, paperweights, a small clock that doesn't work, a dish of keys to locks I can't remember. There is almost nothing on the desk that is useful—such as a pencil sharpener to sharpen all those pencils. I have often wondered if I swept it all clear—Saint Jerome in his cell—would I do better—churn out the odd masterpiece?

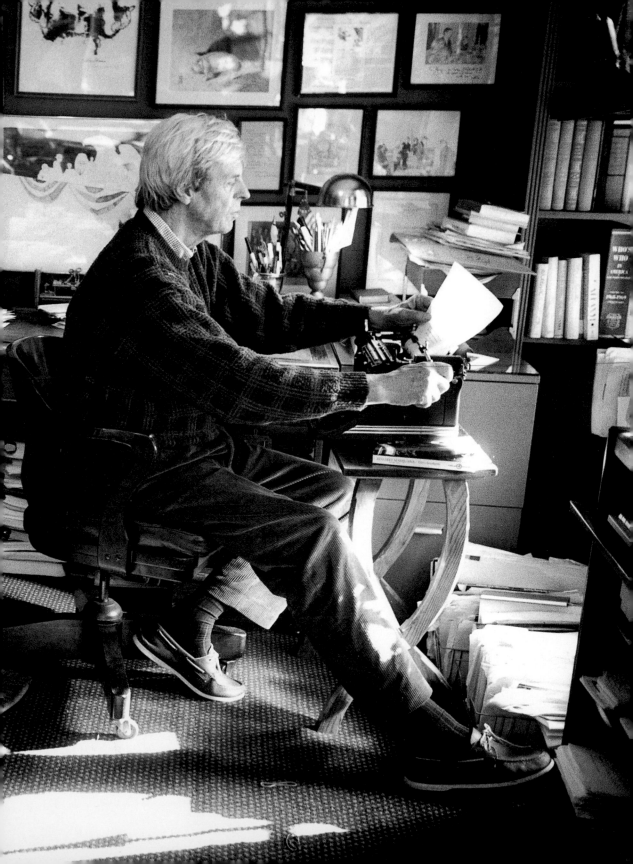

Acknowledgments

I am especially grateful to the following people for their help with this book.

George Plimpton, the cheerful and generous editor of *The Paris Review,* who has graciously permitted me to publish numerous excerpts from the always brilliant "Writers at Work" interviews which have appeared over the years in his fine magazine.

Jonathan Dee, a former editor of *The Paris Review* and the author of the recently published novel, *St. Famous,* who collaborated with me on the text. Resourceful and literate, he was a pleasure to work with.

I am indebted to Harry Evans at Random House for wanting to publish this book and to both Sean Abbott and Wynn Dan for their editing and design skills. Also at Random House, I would like to acknowledge with thanks Kathy Rosenbloom in the production department, production editor Martha Schwartz, Deborah Foley in the permissions department, and Malka Margolies in the publicity department. Crary Pullen and John Loengard assisted with the final editing of the photos. So did my husband, Kurt Vonnegut, and my daughter, Lily.

John Downey, Michael Sorrentino, Larry Lucente, and Meg O'Rourke were invaluable in the preproduction process.

My agent, Amanda Urban, was always supportive and helpful.

I first photographed John Updike in 1967 and my files indicate that I have photographed him on thirty-nine different occasions. I love his writing and I love him. It is an honor to have his introduction as a part of this book.

Needless to say, this book would not exist without the generosity and hospitality of the writers whose portraits and commentary are included. It is to them that I am most grateful for the opportunity to enter into those inner sanctums where they write. It really has been a privilege. It has also been most reassuring to find desks messier than my own.

Jill Krementz

JILL KREMENTZ has photographed over 1,500 writers and is recognized as one of the century's great author portraitists. She is also a well-known photojournalist. Her bestselling photo-essay books for children, including the *Very Young* books and the *How It Feels* series, have inspired and informed generations of children. Krementz lives in New York City and Sagaponack, New York, with her husband, Kurt Vonnegut, and their daughter, Lily.

John Updike

JOHN UPDIKE is our leading man of letters. He is the author of *Rabbit Angstrom,* a tetralogy, and lives in Beverly Farms, Massachusetts.